Lily Poetry Review

EDITOR-IN-CHIEF
Eileen Cleary

ASSOCIATE EDITOR
Christine Jones

CONTRIBUTING POETRY EDITORS
Suzanne Mercury     Lisa Sullivan

FLASH FICTION EDITORS
Mark Jednaszewski     Sarah Walker

ART EDITOR
Martha McCollough

MEDIA AND EVENTS
Rebecca Connors

READERS
Kay Bell, Julie Cyr, Konner Jebb, Elizabeth Mercurio, Chell Nevarro, Tzynya
Pinchback, Renuka Raghavan, Anastasia Vassos, Stacey Walker, Art Zilleruelo

COVER ART, ISSUE 5
*Glass Fish* by Susan Solomon

Joe Biden
Inauguration
1/20/2021

Kamala
Harris
Inauguration
Day
1/20/2021

*drawings by Peter Urkowitz*

Amanda Gorman
inaugural poet
1/20/2021

*drawing by Peter Urkowitz*

# CONTENTS

## Book Reviews:

RIKKI SANTER

## His Way Was To

for Lee Alexander McQueen (1969-2010)

winnow through the cut, armadillos to anchor
bold fruit & smirk's purity.  He cinched with a final
belt the knot of his notable, fragile buccaneer's
scent still nesting in the hides of his dogs.
Long live alien stilettos, shoulder beaks,
blood sighing beneath beaded tattoos.
Tight tight corseted bravado, far-from-fine
lace, the asymmetrical & the ravaged all luxed
for live performance. Opera in the next sequined
dress tarnished & distressed. Couture his anti-thesis,
sullen wings sprouted after a lost mother, his last
note blooming on a weary copy of *The Descent*
*of Man* fringed with orphaned threads, his riddle
for the bite & the bruise.

KUO ZHANG

## The Death of a Rumorer

——In Memory of Doctor Li Wenliang (1986-2020)

He signed "能" (I can) and "明白" (I understand),
dipped in the red inkpad, and fingerprinted
on the LETTER OF ADMONITION
issued by the Wuhan Police Bureau.

He was a rumorer, the very first one
to scare people on December 30th, 2019:
"There are seven SARS-like patients confirmed
at the Wuhan Central Hospital. Be careful!"

In spite of his confession in front of the police,
He told a journalist later in an interview:
"A healthy society shouldn't have one voice only!"
What an unrepentant weasel!

Thank goodness he died! On February 7th, 2020,
after infected by the virus during his work
as an ophthalmologist. Now he had no chance
to quibble or pretend his innocence.

He is a rumorer, forever, on his tombstone,
signed and fingerprinted by himself.

RICHARD KOSTELANETZ    excerpts from **Houroboros**

11

14

18

RICHARD KOSTELANETZ

32

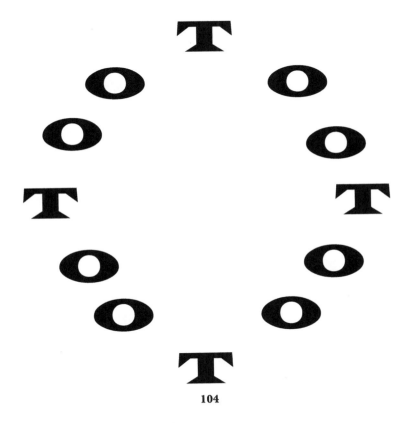

104

RICHARD KOSTELANETZ    excerpts from **Houroboros**

**107**

MILTON JORDAN

## Garden Lessons

Tomorrow you will learn the language
of dirt, the inflections of growing things,
what each stalk drains up out of the earth,
turning one direction then another,
flexible in its strength, bending with wind
and stretching away from every comfort
of lifelessness, reaching each day above
itself and depending on nothing
but that creative tugging toward the sun.

ANNE RIESENBERG

(          ) untouched (          ) untouched (          ) untouched (          ) untouched (          )
(          ) your (          ) palm (          ) your (          ) palm (          ) your (          ) palm (          )
(          ) is (          ) no (          ) is (          ) no (          ) is (          ) no (          )
(          ) longer (          ) longer (          ) longer (          ) longer (          ) longer (          )
(          ) my (          ) cup (          ) my (          ) cup (          ) my (          ) cup (          )
(          ) reservoir (          ) reservoir (          ) reservoir (          ) reservoir (          )
(          ) trumpet flower (          ) trumpet flower (          ) trumpet flower (          )
(          ) volcano (          ) volcano (          ) volcano (          ) volcano (          )
(          ) untouched (          ) untouched (          ) untouched (          )
(          ) your (          ) palm (          ) your (          ) palm (          )
(          ) is (          ) no (          ) is (          ) no (          )
(          ) longer (          ) longer (          ) longer (          )
(          ) my (          ) cup (          ) my (          ) cup (          )
(          ) reservoir (          ) reservoir (          )
(          ) trumpet flower (          ) trumpet flower (          )
(          ) volcano (          ) volcano (          )
(          )

10

can you acknowledge how much has been lost due to your own misperceptions
can you acknowledge how much has been lost due to your own misperceptions
can you acknowledge how much has been lost due to your own misperceptions
can you acknowledge how much has been lost due to your own misperceptions
can you acknowledge how much has been lost due to your own misperceptions
can you acknowledge how much has been lost due to your own misperceptions
**can you acknowledge how much has been lost due to your own misperceptions**
can you acknowledge how much has been lost due to your own misperceptions
**can you acknowledge how much has been lost due to your own misperceptions**
can you acknowledge how much has been lost due to your own misperceptions
can you acknowledge how much has been lost due to your own misperceptions
can you acknowledge how much has been lost due to your own misperceptions
can you acknowledge how much has been lost due to your own misperceptions
can you acknowledge how much has been lost due to your own misperceptions
can you acknowledge how much has been lost due to your own misperceptions
can you acknowledge how much has been lost due to your own misperceptions
can you acknowledge how much has been lost due to your own misperceptions
can you acknowledge how much has been lost due to your own misperceptions
can you acknowledge how much has been lost due to your own misperceptions
**can you acknowledge how much has been lost due to your own misperceptions**
**can you acknowledge how much has been lost due to your own misperceptions**
**can you acknowledge how much has been lost due to your own misperceptions**
can you acknowledge how much has been lost due to your own misperceptions
**can you acknowledge how much has been lost due to your own misperceptions**
can you acknowledge how much has been lost due to your own misperceptions
can you acknowledge how much has been lost due to your own misperceptions
can you acknowledge how much has been lost due to your own misperceptions
can you acknowledge how much has been lost due to your own misperceptions
can you acknowledge how much has been lost due to your own misperceptions
can you acknowledge how much has been lost due to your own misperceptions
can you acknowledge how much has been lost due to your own misperceptions
can you acknowledge how much has been lost due to your own misperceptions
can you acknowledge how much has been lost due to your own misperceptions
**can you acknowledge how much has been lost due to your own misperceptions**
can you acknowledge how much has been lost due to your own misperceptions
**can you acknowledge how much has been lost due to your own misperceptions**
can you acknowledge how much has been lost due to your own misperceptions
can you acknowledge how much has been lost due to your own misperceptions
can you acknowledge how much has been lost due to your own misperceptions
can you acknowledge how much has been lost due to your own misperceptions
can you acknowledge how much has been lost due to your own misperceptions
can you acknowledge how much has been lost due to your own misperceptions
can you acknowledge how much has been lost due to your own misperceptions

MARTIN WILLITTS JR

## Snow Moon, Hunger Moon

She starved for better days. Snow plows through,
relentless and maddened with hunger to devour every day,
spitting out the day's bones after sucking out the marrow.
She cannot see outside anymore. Snow delivers
power-driven blows, fistfuls, lean and leaner,
boxing her ears. The food she had stored has dwindled.
Half-moons of leftovers, ice blocks of hard tack,
remnants of light. She has to check her health care proxy.
There are no tracks to her house. The world is blinding.
She begins gnawing on her shadow, trying to make it last.

## Doubt

There's clutter around—the kind her neighbors
worry about. She dreams a tent with seams
almost torn. Or drapes hiding opened doors
she can't walk through. Costume jewelry gleams
under yesterday's papers. There's no truth
in her closed voice here. Visions have to mean
something. She just can't believe untaught lore
on hot nights like this one. She wants to sing
but speech, flat and dull, is all that's allowed
now. You don't trust whatever she brings
to anyone's dream. She falls deeply, loud
as a stage gunshot. Nights where nothing's true
bother her. The telephones ring and ring.

PAULA CAMACHO

**Presencia**

KAREN FRIEDLAND

## Life as a Faded Photograph from the '70s

*Go wait for Daddy* our mother would say—
on the front concrete steps
before the trees grew big,
before the walkway turned to a tasteful slate.

So we waited for Daddy
in the hazy, '70s sunshine,
in the hideously-patterned clothing of the day.

It was a ruse to get rid of us,
as it turned out—
but still we waited, Zen-like,
as if trapped in amber,
for what might've been hours.

Only to re-appear years later
as a faded yellow and green photograph,
when a certain song comes on the radio.

ISAAC RANKIN

## Regeneration

In the picture
he is licking batter off the spatula in the backyard
because something encoded in his DNA tells him:
this is what we do with batter-covered spatulas.
He's looking more like me than most days so
I text his grandmother the photo to strengthen our side's case
and because quarantining can be lonely
when spring buzzes and sprouts forth from every living thing in sight.
I can sense her searching for the right emojis
on the other end of the endless ellipsis
and brace myself.
Instead:
Did you ever imagine you could love someone so much?
He's giggling now,
zigzagging sugardrunk through the yard
as I search for the right words...
this tiny human life raft
floating out in the ocean of all loves
between beings of and for one another.

ANNA M. WARROCK

## Others will be young

Repeating calls
of flight-weary     rangeless birds

insects
diswinged     multisexual
frogs

brown and white
bears mixed
into ones that     can swim

but cannot     haul out     to live
to hear     the

broom sweep up
debris     and bone

abandoned changes
clang     their final bells     again

choice     a strait     not straight
hemmed in     by fire

we     will be old     when
the elephants     disappear

WENDY BOOYDEGRAAFF

## Teacher

He sits behind his desk, early light shining rays on the crumpled papers stacked in the hand-in box. An old building, drafty and bulky, creaking doors announce the one who comes today, sneaking in from the morning playground. Eliot, the teacher says, what's going on? Eliot hands him the lined paper, crisp except for the finger smear from the school's hash brown breakfast. This is Eliot's first offering to his teacher, though the teacher has received many such offerings throughout his thirty-two-year career. The first offering deserves a special reverence, a certain surprise and thoughtfulness, dependent on the character of the student. Every student is an individual, a small promise that can be unfolded only the smallest bit, but the teacher has a premonition beyond the school's dirty alleyway and bit of smudged grass for soccer, a predetermination that the first petal peeled back allows the rest of the promise to blossom. The teacher won't know, of course he can never know, but it's more than talent, he believes. It is that drive, that inspiration deep inside, a fat bud that blooms large, a hibiscus, maybe, but not so common. Last year it was Denise, and she didn't have a paper, she had a succinct current events stream that allowed him to turn off the radio on the daily commute, listen to the wheels on pavement, hear the brakes squeak out the morning moisture.

The teacher takes the paper, scans the first lines, raises his bushy eyebrows in interest. He clears his throat. Eliot, did you want to read this for me? Eliot ducks his head, shakes his head. No, the teacher says, but did you want me to read it aloud? Eliot takes a step back, his head burrowing down, his chin pressing into his chest. The teacher returns to the paper, he reads it silently, slowly, then reads it again. Eliot, you wrote this? the teacher says. You wrote this. Hmm. I was thinking of—, and the teacher mentions the name of a poet they had studied yesterday, because the child would know who it was, and Eliot now has a spider's thread of connection to a poet who, for the rest of his life, whenever that poet's name is mentioned or seen in print, or found in a list on the syllabus, Eliot himself will weave another thread. The teacher will read another poem by this poet today, even though the poetry unit is done, and he will continue to find ways to incorporate this poet's name into the other subjects. Eliot, this is good, this is very good, the teacher

says. He holds out the paper to Eliot and Eliot shakes his head. It's for you, he says. Okay, the teacher says. Here's what I'll do. He goes down the stairs, the old creaking stairs, Eliot following, and walks into the teacher's lounge where the copier sits in the corner. Eliot hovers around the door, though there is only one other teacher in the lounge, filling her mug with coffee. The teacher comes back with the poem and its copy. Here, he says, handing Eliot the lined paper. You keep the original. Eliot takes the paper and folds it into fourths and stuffs it into his jeans pocket. You keep it in a safe place, the teacher says. Eliot looks up and sees he's serious. You want to go back outside? They can hear the other kids on the playground, the basketballs bouncing, the jump ropes skipping, the voices calling. The morning light, a little more yellow now, shines hazily down the hallway. Eliot looks at the door to the outside, and he looks up the stairs to the classroom. He shrugs. Come on then, the teacher says, and walks heavily up the stairs, one foot in front of the other. He thinks he hears the boy behind him, but he can't be sure unless he turns around. He thinks the boy will come upstairs, pull a fresh sheet of lined paper from the stack, sharpen his pencil, and write for the six minutes left before the bell rings. But he knows the day is sunny and the air is light and there are few days that feel like this one and a poet could choose either.

Delicate, Discarded

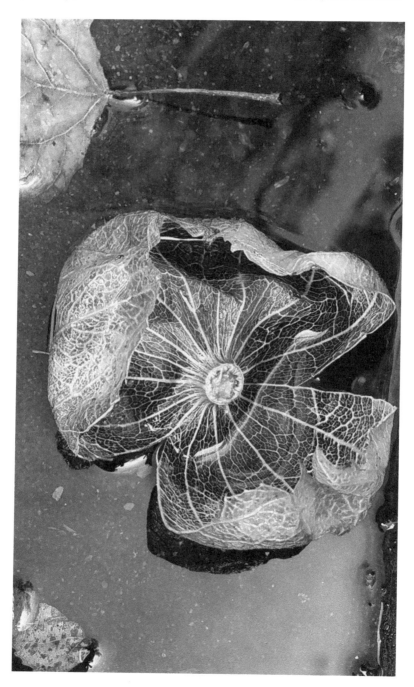

CAPRICE GARVIN

## The End of Our Friendship

Judgment crept in, like the ants this past fall.
One last warm spell brought us together,
and a sweetness of crumbs.

At first, only a mar, a single violation.
Then, a rapidity of darkness I thought impossible
to crush. I fell to my knees,

Became the placer of cinnamon around the edge.
Until someone told me, even such mercy
gnaws painfully through exoskeletons.

You scrubbed with vinegar, as with prayer,
prayed for reclaiming of our common ground,
but still the onslaught.

And we, now acidic, now crumpling,
watched.
Bodies, lives, so industrious,

so unaware,
came into the softness of tissue,
and there was a pressure,

and there was a holding of breath.
Then, a whirl-pooling,
a flushing away, and our hands

were left wreaking of vinegar;
a scent that's said to confuse the path
of the Hungry gathering crumbs.

KEVIN RICHARD WHITE

## Army of Ants

My dad used to store his spices on the shelf above the oven. That's how the kitchen went up in flames. They fell into the burner, the caps busting open, and that was it. But I wasn't there to see it; I was behind the bushes next door making out with the neighbor.

Being a ten-year-old is strange. You see so much and take no note of it, only the destructive things, the subliminal things.

Of course, it was going very poorly—such fast movements between a young boy and a young girl can only lead to fumbling and bumbling, and there was a lot of stopping to ask if we were alright.

I looked down, midway through, and saw her cherry popsicle resting in the grass—an army of ants munching and scurrying all around, lapping up as much sugar and additives as possible. A moment that comes rarely, much like this very own.

She did stop at one point to ask why smoke was coming out of my kitchen window. I took a moment to consider it, but I answered with the truth: Dad was a shit cook and he was probably trying to fry fish again.

But as prepubescent kissing often goes, we grew tired of it, even ashamed. We both went home, promising to talk about it later, and of course not to tell our parents. She left her popsicle on the ground and I watched the ants for a while, thought about their strong bodies. They moved so fast.

I went back home just as the fire was under control. Black ash burned onto the crusty and floral baby blue wallpaper, the oven scarred and streaked from damage, dinner thrown onto the floor like feed for animals. Dad was fanning the smoke with Mom's favorite tea towel. He screamed at me, wanted to know where I was. I didn't have an answer. I wanted to know when dinner would be ready. He stood there, crying as he fanned the flames. I'll never forget that sight. I was a bastard for asking such a dumb question, but I remember thinking he should be stronger than that.

Later that night, I stood outside her window, watching her do homework. I wanted to try kissing again. I tapped the glass, but she didn't answer. Instead, she smiled. I didn't care about any fire. I only cared about her fire. But I went home. Tomorrow was another day.

On my front porch were the remains of dinner that Dad had decided to toss there. As expected, the ants were there. I sat next to them, put the food on my hand, and watched them climb on, becoming a second skin.

JASMINE LEDESMA

## My Cells, My Snakeskin

It is July so everything burns. Avenue X smells like dying fish and simmering sludge. The sidewalk has cigarette burns. I am sixteen and staying with my dad for the summer. He lives in the backside of Brooklyn. For the other ten months of the year, I live in the parched suburbs of Texas with my mother. I've got at least another month left until I'm due back.

My hair is a strung-out crown. Frazzled waves of teddy bear brown hair pour down my back. I'm walking home from the nearest pharmacy where I have spent two hundred dollars on various useless items: brown hair dye, a bracelet making kit, three health magazines, a bottle of glitter, and a dog toy. Just in case.

I've been feeling absolutely shiny. Depression is a word I've forgotten how to pronounce. Two weeks ago, I suddenly felt wide awake. Like somebody replaced the air with smoke. It is unlike anything I've ever experienced before. I don't need to sleep anymore. I stay up all night trying to make something happen. I've been writing musicals into my phone. Voice memos of mumbled, choppy operas about tennis shoes and lesbians. I'm going to win a big award, I've convinced myself. A Tony, Emmy, or Grammy—they're all mine. I've already begun writing my acceptance speech. And of course, I have nobody to thank but myself.

I don't know it yet—won't know it for at least another year—but I am experiencing my first manic episode. Even if I did know, I wouldn't feel any less magic. If I cut myself open, light would leak out. I am a party and everybody is invited.

As I get closer to the entrance of my building, I'm so entranced by my thoughts that I don't notice the man standing against the lobby door.

"You dropped something," he says.

I look at him, my head snapping up from the ground like a flipphone. There's a tear tattoo beneath his left eye. I can't remember if that means his loved one died or if he killed someone. He's smiling, regardless. His front tooth is lined with gold that twinkles beneath the mid-afternoon sun.

"Huh?" I ask, looking behind me and then into my bag.

Everything is still there, cluttered together. I can't remember what the glitter is for.

"You dropped something," he says again, standing straighter.

He pulls his phone out of his back pocket in one swift motion, offering it to me.

"Your number into my phone."

I laugh like a live studio audience. I even squeal. The man forces out a chuckle, unsure of what to do. He's most likely not used to reaction.

"Oh!" I say in between giggles, walking past him into the lobby.

The elevator is waiting for me like a voicemail. I pull on the door and slip inside, oblivious to the urine on the floor, reeking like blood gone sour, or the swastika carved onto the wall. I click the sixth-floor button and wait for the door to close. I look into the camera calmly perched in the upper right corner of the elevator. It is undoubtedly broken but I stare into it anyway.

And I grin.

GABE DURHAM

## My Gorgeous Opinions

Check out my gorgeous opinions backlit tastefully behind glass.

That one is cute. That one is the bad boy. That one is so rare no one knows to ask for it. That one is more in charge of me than I am of it. That one flipped this week when a prestigious friend mocked what she didn't know I loved deeply. I'm still getting used to what I now think.

And there with the dimples is my star opinion, the one I trot out Sundays and take pictures with, although I quietly harbor its opposite.

In the vault at our feet I keep my uglier opinions, the scrappy hand-biters fed only blood, fear, and hearsay, the dregs of my convictions whose airing would ruin me. That I can't share them makes me cherish them most.

ASHLEY KUNSA

# White Dwarf

So you decide to have both lives. The one you've spent
eons hewing from the rock face, the other you walked into,

sleepy-eyed, a bar that went up on the corner overnight. Buy the shoes, comb the hair,
make yourself presentable: the universe will count your mistakes

like raffle tickets. This double living, it will take some doing, and there will be hours
when you inhabit neither the one world nor the other, but stand outside yourself

observing the trucks in their gentle commotion on the interstate, as sometimes
a person must do when choosing who to be. As we are always choosing,

whether we know it or not. And the mountains will still
rise in their quotidian way toward stars that dwarf nearly this entire solar system—

Antares, Rigel, Polaris Australis—and the cattle still graze a little to the left
or to the right of where yesterday they took this same feed.

Cattle—that's what they call cows out here, where the speed limit's eighty
which means ninety-two even in this old Chevy,

and we haven't seen a cop for three hundred miles of gray carving up
this yellow land that floods the margins like an answer to space itself.

This morning I heard the first known supernova
lingered in the sky for eight months; the Chinese called it the "guest star."

Isn't that lovely? How the mountains must have shivered under its impossible light.
They have only the one long life, and they make of it what they will.

PAULA COLANGELO

## Let's Review

Let's say my parents live on,
watching from a balcony.

Both blinded and backlit,
I imagine them applauding,

an exercise in object permanence.
Accident that I was/am,

accident of language––how I
never understood

until old enough,
until I learned to project my voice.

JESSICA MEHTA

## The Green Fig Tree in the Story

You are my fig, how incredible
that another poet couldn't choose.
You don't sit, idle, so incredibly
selfish that you refuse to hear
your heart screaming. All those riches
hanging pregnant, skins splitting
at your flanks—they're distractions. Some
call them temptations, but not me.
I see past them, straight
to your center
and the sweet explosions beneath.

JESSICA MEHTA

## A Tiger for Christmas

When I gave you a tiger, I didn't know
he would become our Christmas tradition,
our own *little Saigon*—years older than wild tigers,
hundreds of pounds less, with a craving for hearts
of horses from the slaughterhouse across town.
Like you, he was born in a cage, the pull
of alone-dom strong as his haunches, thick
as the canines that cracked down on stallion bone
like *murukku*. Like you, his eyes tracked
those who stared, the passerby with heavy cameras,
the brave ones who got too close. He was ours
through his end years, past the mourning days
for his sister. He didn't pounce, didn't preen,
didn't growl like the others. *He knows
he's a tiger,* you said. And for that,
I gave him to you, a beast spilling
with killing power and a taste for tired love muscles.

BRANDY BARENTS

## Holidays

After dessert, I'd leave her by herself
and drive the three of you to Maryland
where he had his new son and wife.

In some dream between states,
you'd count the houses with lights
watch out the windows for snow.

I'd turn up the radio
and we'd sing in the dark car down
the near-empty highway.

They won't say it, so I'll tell you:
things were good when you first came.
You sang in your cribs,

stood up in your highchairs,
dropped food just to watch
us pick it up again.

LAURIE MCCULLOCH

## The Brave Must Land Softly (An Ambush)

Through the kitchen window she spies the parachute, a tiny scrap of cloth poking through the melting snow. Attached to a plastic soldier once, it lies unburdened, flat as a collapsed lung.

He commandeered a whole troop, she remembers. Sergeants and lieutenants and bilious green captains wielding toothpick bayonets. They plummeted fearlessly from the first branch of the Manitoba maple in the back yard to where he waited, with boy-sticky hands, to hurl them skyward again and again.

One time the paratroopers went rogue and drifted into No Man's Land on the other side of the boxwood hedge. He was forced to mount a rescue mission then. Secure the perimeter and make 'pop-pop' noises to engage the Rottweiler next door.

From the window she watched him crawl under the loose boards of the broken fence, not minding the stains that would have to be pre-soaked later; forgetting, for a moment, the barbed-wire scar in his hairline, his invisible foe.

Soon he would become a casualty. But not then. Not when he stood victorious in the neighbor's yard, negotiating a truce with the slobbering General, twisting and squirming to avoid the dog's eager tongue. Explosions of giggles. Mushroom clouds of joy. Shrapnel everywhere, everywhere.

She presses her palms to the glass and prays for spring winds to breathe the buried fragment alive.

"Please," she whispers. Or, "Peace."

Either way, she wills this memory to unfurl above her, to save her from shattering (again) on impact.

KIMAYA KULKARNI

## Sapiens

She sits down on the cold stone floor and settles back between the legs of her ancestor. Her hair let down, she closes her eyes as the wrinkled fingers find every dry space on her scalp and flourish it with coconut oil. Ancestor mumbles about how ill-kept this hair is, how stunted their growth, how brittle their texture. *My hair came down till my waist when I was your age.* Ancestor's hands, which shake doing the simplest of tasks, become surgically precisive when her mind is busy reprimanding her descendent. *You should eat methi seeds every day, and boil kadulimb leaves and drink the water. Only that can help this mess.*

The gentle assault of the fingers on her head has tipped the descendent over to a blurry träumerei, full of tinkling bangles and joyous laughter, a memory of breathlessness as she successfully jumps over chalk-drawn squares and makes it to the other side—until the fingers are suddenly replaced by a sharp, thin-toothed comb that guts through the oiled hair. She screams in pain and yanks her hair away, looking accusingly at her ancestor. *How will the lice get out otherwise?* There is no lice since shikekai got replaced with chemicals, there is only ritual, and short-lived hair.

After the hair is washed and dried and smells of alien flowers, the lineage distorted, impossible to be broken, the sapiens move along in time resolving and creating new discrepancies in their way of life, holding on to the make-believe lice and letting go of the hair fruit.

MARY BUCHINGER

# / haɪv /as in "a *hive* of clouds"

enviable industry;

purposeful imbalance;   what whizzes off

to discover;   sweet gold humming;   furious; interdependent;

armed;   jarring;   consists of sticky propolis & populace;   center

decentered;   what is royal;   inherited;   the shelter &  the sheltered;

edible jewel;   internal storm system;   settled with smoke  or cold;

sun-made &   driven;   co-op;   whole  rolled     prairies  &  yellow

orchards     snug  in its  keep;     abundance;   winged  cupbearers;

sea-sick; inventive language of movement & distance;  easily stunned;

great;   horde of hoarders; spinners of solstice; intimate with blossom

CAPRICE GARVIN

## Our Bees of Notre-Dame

Things that cannot fall—fall.
Sacred chalices, vials of saintly blood.
Millennia of faith and refuge. Key-holes.

When the spire slips,
like a tongue from a half-believed utterance,
the nave swallows itself whole, then belches up brick dust and charred eulogies.

Jeer-sharp sparks swarm over the crowd,
circling even now, so that as we return to the courtyard,
a thorny shadow of ridicule sticks to our soles.

Until an old woman says, A swarm overtook his face. But left no sting.
No sting in the mouth of Saint Ambrose, our Patron Saint of Bees.

At this, the eyes of the skull snap open—wax octagons unmelted, un-blurred.
No sting. But a drop of honey on the tongue. The sweetness of oratory.

As though by witchery, a black swathe of soot lightens into a fineness of foulard,
lifts, a hum in each thread. Not black then, but gold, a stitchery of bees,
each pinpointing a higher plane.

*Like rosary beads*, a young nun whispers,
and counts each bee fifty times.

The crone points higher.
There are more, she says.

And indeed, they are everywhere,
rising from rooftops, from humble boxes,
flowers offering altar-wine, beekeepers climbing hidden stairs,
and they in their softness, rising and wrapping the air in the holy cloth of flight.

This morning, a glisten of wings hangs on the air,
a prayer for a city of hives.

35

JAILENE CORDERO

**Garden**

She opens your chest—an incision with a small trowel snug in the grip of her hand. From between her fingers, she sprinkles seeds into you, dresses them with dirt, and retches water to fill your stomach. Her kiss, a small press of lips, doesn't cement all your broken ribs. Rounded nails stitch the skin and leaves a shiny, pink, jagged scar from neck to navel.

On the tip of her toes, she orbits you. The sheer fabric of her gown burns iridescent as it rises and sets past her waist.

Roots puncture your lungs and cling, weak and unrelenting, to the veins of your heart. You grimace with a rushed breath and cradle your left arm over your abdomen.

She brushes your hair back and pulls your head onto her lap. Thighs sear the goosebumps from your skin—hush the tremors grinding underneath.

You look at her—the scleras swallow your irises.

She raises an eyebrow, and coos, "So?"

Comets and meteorites whiz behind her. "I *adore* you."

She chuckles with you, though you aren't laughing. She cackles at you and it spikes your blood pressure.

Stems grow taller and scrape your muscles. Leaves jab at joints. Thorns caress tendons. A stalk stabs your tongue, but their bright green paint smiles on her face.

Buds swell against your nerves. Petals fill the space between skull and brain. June or August? Mercury pools on your Cupid's bow, but the red amplifies the glitter as she grabs the flowers and their sparkle refracts.

You try to whisper in a gust of a voice, but your vocal cords splinter. Kidneys overflow with tears. You open your eyes—gaze half-lidded and noisy.

She hovers over you, dimples deep in her cheeks. The white of her molars intensifies with the marvel of your withered skin. She wheezes, rabid, as you tint purple, blue, gray. The pungency of your body wills her lustrous. She rolls on you and a sound escapes the back of her throat—tensed, released, sated.

She buries your compost—no dirt under her nails. Beside her pearls and peridots, in a glass box, she stuffs the littlest of your bones.

You grow and expand, covering her entire property—from the front porch to the ends of the backyard. Cuttings of you planted in corner-stacked pots on the living room floor and hangings over her bed.

You sprout wild and away from her house too—into fields across small towns and bushes in giant cities. Colorful parts of you float on freshwater and smuggle into countries with the waves.

She bores in awe.

You're in bloom.

CONNEMARA WADSWORTH

## All I Ask

I want to be with you
walk in circles

find myself in another
room, come back

or stand among
the untamable

sun-baked climbing roses
I trim, trim

you have tucked into
another place

as if the well of your body
cannot hold you

I cry *do not let it empty*—
all I ask

is for you to tell me
what you choose

CONNEMARA WADSWORTH

## The Hurricane, the Windows, the Rain

the cabin's
wall of windows

I watch the rain,
curtains of water

the wall of it between
glass and forest

an emptiness made full
by being enclosed

dry space, full
and spare where

nothing is asked
only what is there

what remains
only what I bring to it

the rain, the walls
the trees, the rain

the quiet, my desk
the windows

the rain

CONNEMARA WADSWORTH

## Cows in the Apples

The two obedient Guernseys
and the bull-headed Jersey
saunter back from milking,
udders swinging empty

as they pass the meadow
to the lower pasture
in this the time after
the fat of summer,

and they are downwind
from the apple trees.
The Jersey breaks away,
the rest follow,

plant themselves on
the perfumed carpet
of fermenting drops,
ignore angry bees

as eager and sated
as they. No amount
of bullying can move
the hulks trampling

willy-nilly on their feast,
they shaking their heads,
pushing us back. They will
have their fill

before they swagger
down the road, happy
drunks licking bits
of sweet apple off wet lips.

CAPRICE GARVIN

## Midden

Refuse of thought, this backyard. Earth closet, broken from house.
And you, Archeologist, buried in midden.

How to know holes, cracks, pieces from within?
Fossil-worry spirals deeper into its own stasis.

Newspaper-waves churn neighboring fence into unsettling nearness.
Less than six feet away, that bleaching approach of absence,

that crackling of a lost epoch's words. An urchin
of frayed rope left over from spring, and shards of—

*Shell fragments*, you tell yourself.
How they pile. How they stack up, so many broken things,

once beautiful, translucent, golden things,
now a plunge, a terrible current.

But remember when you walked by the edge,
and the only worrying was ocean worrying depth into sea-glass.

Windows washed the shore then.
You filled your pockets with seeing.

I know your secret.
You dug castles from grit, set windows

like jewels, and after, when a voice said *fill the holes*,
you waited. When no one was looking, you climbed in

just to know something measured.
You let yourself feel the walls.

You tended the emptiness,
made it empty of all but sand, pebble, a seagull's bones.

The ocean helped you, washing in.
The panes tumbled back into their own darkness.

LILIA DOBOS

# Midden

There are so many ways to carry the weight
of her.

There's a dream where she's cooking
    me dinner and she doesn't need

help. There's a dream where her crumbling
    body tells me to watch

my step. There's a memory of her stroking
    my hair when I'm sick

asleep, and these bowls of winter
    soup she serves from her fingers'

bones. They're not

mine. Her shoes are horned into
    the ribs of someone else's closet. Her diamond ring reflects

the light from someone else's bathroom
    mirror, and I'm not there

to get caught in the glint of it.

But still, the heavy –
        but still, the ache –
            but still, the way we carry
                every ounce.

JAN LAPERLE

# Radio Show

Yesterday morning Rose ate the insides of a lemon filled donut and the edges of a blueberry danish. Her husband ate the edges of the lemon filled donut. The sweetness was upon them: they kissed. The day was pretty and the husband left into it beneath his suit coat. His shoes squeaked across the kitchen floor (Rose had mopped the day before).

The day before yesterday had not been as sweet as yesterday. She had stayed home and listened to a story on the radio about people hurting people. Even when she flipped the radio switch the stories kept playing into her rooms. The day before yesterday she was sewing curtains from an old set of bed sheets. She ironed the edges of the sheets in perfect lines that reached out to her left and right and kept going and going and the women from the radio stories that the men had hurt and the men from the stories that the women had hurt gathered in her basement. They stood in the puddles where the rain leaked in. They stood behind her ironing board and waited. *Go away*, she whispered as she ironed and ironed and ironed.

*Go away*, she whispered as she climbed the wooden stairs and again she whispered it as she sewed the stitches along the edges of her ironed bed sheets. The women and the men spoke to her as she sewed and their voices grew louder and louder as the stories like terrible clocks ticked toward their climaxes with great alarm. Rose finished her curtains quickly; the motor of the machine hummed like a car. Her foot pushed the pedal to the floorboards. The men and women from the radio show were yanking her as if she were leashed.

Rose hollered all kinds of things at the men and women. She ripped the old curtains from the high rods; the dust clouded. All the shouting, from Rose, from the men and women, rattled the windowpanes, the metal rods clattering to the floor. Rose switched the radio back on, turning the volume high, hoping they would return from where they came from. She pounded the walls with a hammer, the furniture, too. She chased the men and women from the radio show around the room and they seemed pleased with the attention and the chase and they

knocked over furniture and books from the shelves and vases from the shelf-tops. Curtains were ripped from the windows. The screen ripped from the door when the chase moved to the yard.

Rose's husband returned from work at 5:10 p.m. His wife was pulling chicken from the oven. The house was quite pretty, as always (new vases on the shelf-tops opened into new blossoms). He complimented her new curtains, and parted them (not at all a surprising test of functionality), but what he saw there was unusual: his backyard filled with birds, every one without wings. In his paper sack from town was a donut and a danish and a cinnamon roll, too, which he handed to Rose. He kissed her before she could get to the window. They ate their chicken at the table: each hoping their gentle conversation would drown the sound of the terrible squawks rising and falling in the darkening yard.

CAPRICE GARVIN

## Grasp

To undo his leaving, she lets regret close in,
lets its hungry eye, eye. The way the hawk circling,
stops all movement: hare; worm; ground.
She does not consider her father's restless walks.
She thinks she moved too much as a child.

STEPHANIE ARNETT

BARBARA SIEGEL CARLSON

## Shadow of the Untouchable

Standing out along the path in the Public Garden among spit, broken twigs, geese turds, crushed winter berries and patches of dirty snow, a man with a raw unshaven face and red swollen hands reads on a green bench. In front of him a pigeon with a green shimmer on its neck. Just past him, a gray feather is slightly lifting on a step, which leads to the bronze statue of an angel holding a bowl of bread—the crumbs it perpetually holds to cast. A child's glove is propped on a post of the iron gate, its other buried somewhere in the world.

LAURA HOFFMAN KELLY

## Southern-Fried Sacraments

we grew up- filthy things
in paint-by-number pastoral scenes
swatting flies with the fervor
of little televangelists

mama spoke in tongues
with analogue angels
whose homogenous grace
spread like Country Crock
on white Wonder Bread-Jesus

daddy left us behind
with the frying hiss of bologna
said the kitchen flies
flew up from hell
to tickle him crazy

mama died later
at a table waiting
for the laparoscopic
band of the lord
to save her

FRANCES MAC

## Flood

A house of splintered wood teeters,
the lawn bellies of blades that shimmer
like scales under a siege of dusk.
A house that wobbles, heaves on its
beams, bows like a beaten dog under
windy blows. Muddy waters stealth up
the walls, from the trench crawl
higher and higher to some darkened keep.
An angry froth churns around our knees,
paint puckers, pops, sloughs off like skin,
glass punctuates the storm – we bleed.

This house will not be saved, this house
of fist holes, of popcorn ceilings,
of blinds that always settle crooked.
This house is ours, and I mean to see it
off proper, to witness every secret
plucked from the earth and follow
their scurries to new graves. You say
you have no time for floods, impatience
metered in the ticks of your watch,
in your urgent breaths upon me,
and I know it like I know these walls –

something else is drowning
with our blurry artifacts. Your arms signal
from the roof how ready you are
to surrender.

BRUCE MCRAE

## In Retrograde

In the house of the blind astronomer.
Among a scrabble of charts and graphs.
In retrograde, the cosmos unperturbed.

We hear the extraordinary plainly spoken.
We taste evanescent radiation.
We see the unseen things, which are
by definition unattainable.

You're in his workshop, biding an old cosmology.
In one drawer are giant blue suns.
On a shelf, the hallmarks of anti-gravity.
And everywhere is the scribble of his guesswork.

The home of the weepy-eyed somnambulist.
There's no telescope or light detected,
just the scent of interstellar cold.
A hint of universal code.
A soupcon of the electro-chemical.

Visitor, it's always night in his observatory.
It's always night in the eyeless dark,
when brilliance ranks among the stars.
            You can't see for looking.

BRUCE MCRAE

**Empire of What**

Comets crashing and the emperor
has new clothes, new teeth, new girlfriends.
Continents adrift and the emperor
has a new car, new haircut, new horizons
upon which to cast his bloated glare.

And what is the state of his empire?
The empire, I'm afraid to tell you,
has fallen upon difficult times.
Fallen like a last soldier or archangel.
Like a fiery stone from the auspices of heaven.

BRUCE MCRAE

## Going Bust

A shop that doesn't sell anything.
A quiet *cul de sac*, evening settling in,
the shop empty for want of acumen and savvy.
Even the mice, scurrying along the quarter-round,
are made sullen with disappointment.

As darkness palls we can't help but hear
the sound of someone softly sobbing.
It's the owner, bankrupt, wringing their hands
like a tear-stained handkerchief.
The one with little business sense
in a world of ill proportion.

ACE BOGGESS

## "If You Saw a Robbery, Would You Report It?"

[question asked by Nathan D. Horowitz]

Stared at my reflection in both sides of the blade:
first eyes two olives in a glass,
the others gray & menacing as storm clouds

miles away but coming. Not as a witness,
so don't know if I have an answer.
Crooks stick together; victims, too.

Can I choose an ethic of remorse
rather than solidarity? Give me
more details. Is there blood?

Must there be? What profit motivates,
what need? Could be Jean Valjean
rescuing siblings with a loaf of bread

or a junkie agonizing from his own
approaching absence. Where is the proverb
God wants snitches? Let me

have an hour to think before police arrive.
I'll decide between robber & mark,
thankful to be neither one for once.

TODD HELDT

## In this draft the woman dies.

The smoke fans into the sky like dark hair
spreads across a pillow. Two lovers fall
in love with the same old sign that marked
a liquor store but now sells cameras -
the new owners couldn't bear to replace
the old neon because of memories
or nostalgia. She's still dead, by the way,
so nothing has changed. But sometimes I am
the homeless man on the corner of North
and Western who considers the pigeons
as friends. They gather around my feet and
perch on my arms. They respond to their names,
and circle back to my outstretched hands.
That is enough. I will not rewrite this.

SAMN STOCKWELL

## Distance and Temerity

The sparrows were enamored
but sounded like a congregation of worried mothers.

Distance and Temerity flew
from Central Park to the bakery.
Like dark flakes, they fluttered to the ground
and ate crumbs of coffee cake and cinnamon buns.

Everyone emerged from the bakery
with white paper bags held out like lamps
and hot cups of coffee jiggling in the other hand.

Joggers zoomed by in black tights and headbands.
*Fleet,* said Distance.
*Sweet as plums,* agreed Temerity, inhaling.

After the joggers, the businesswomen, the businessmen
dragging brown briefcases
or swinging them like dull missiles.

Then, children going to school, the girls in pink and purple,
the boys in blue and red, with secrets like feathers.

The sidewalk was getting thin, a few shoppers and the homeless.

*A snarl of chaff left as they leap?*
*Yes,* remarked the other, *they light and thunder.*

Is there a sparrow waking at 2 a.m.,
knowing he's alone? No.

MARTHA MCCOLLLOUGH

## No Rescue

It's a clown show but with guns instead of air horns / a camouflaged man swaggers through Denny's / waggling his semiautomatic / It's hard to tell if he intends to shoot / and if so, how many, whom / Come hide in the walk-in / maybe he doesn't know that trick.

MARTHA MCCOLLLOUGH

## Him Again

the hero arrives
    like any catastrophe
        one more
            in a series of disasters

he was bound to show up
    behind the dragon or ogre
        vested at first with a certain glamor
        a man without fear

but soon you start to feel judged
    and by that musclehead!
        it's nearly as awkward
        as having a saint in town

as for the ladies
    sometimes he takes one up
        like pocketing a shiny dime in the driveway
        then he forgets

MARTHA MCCOLLLOUGH

## To Speak

the moon at zenith grown remote and chilly
/ unreachable as someone you admired / but
then somehow you couldn't speak and too late
now / her ambiguous half-smile fading as she
climbs in a stately procession of one / do you
see me / seated on a turtle sandbox / making
yet another wish

HALEY WOONING

## nox   nuit   **night**

where nyx is mixed in

cauldrons with garnet

star and milky mist

a moon whose ink nears

that broom-borne writhe

where middle now like a limb

turned lift towards funeral

loosened and wind-raw bone

night liquid a touch of cloth or flesh

a thing like a veil to be worn, as finite

midnight impassioned and

full with the folding of each

lover-ire iron churned - each

crossroads stained by the

houndworn cloak black and asked

by nyx for bleeding, and given,

no more masked by silent others

LISA C. TAYLOR

## Imposter

We sang *Amazing Grace*
to the walk light and fire hydrant.
Shadows of buildings inhaled exhaust
and I counted my remaining freedoms,
conjured gods,
while your fever rose.

*Night is a thief,* you said.

Streetlights beckoned
and we wandered
into a part of town
with shelter
for the healthy poor.
You handed the girl with a headscarf
your woolen coat.

The night after
you stopped breathing,
the moon was bloated
and incomplete.
Only a handful of stars showed up.

I spun into cities I didn't know,
opened doors
to meet your sisters, uncles,
foreign friends, tentative and visible.

I called you the name you chose
as if you would answer
but your family
repeated a name you shed

like the coat you no longer needed
because you were warm enough

and that girl, the one
with the headscarf
was shivering.

BRETT BIEBEL

## Three Frog Night

Two weeks after Mom left, my brother and I caught three frogs out near the lake. We named them Buddy Hoppy, Ribbit Valens, and The Big Hopper, and my brother taped them to this model airplane he'd got for Christmas like three years before. It was a P-40 Warhawk. He still had some of the glue. We climbed out the bathroom window and onto the roof sometime after Dad fell asleep, or maybe he was just lying on the floor watching TV, I don't know.

"Say a prayer, Asshole," said my brother, but I couldn't think of any just then, so I said the names of stars, only I didn't know many of those either.

"Beetle Juice," I think I said. "Alpha Centauri," and then the plane was in the air. It didn't exactly fly. More like it spun and flipped like a football and rammed into this big tree we had to cut down a couple years later, and then we climbed back in through the window and ran downstairs to scope the wreckage. My brother had a lighter. He said we were going to make a pile out of the rubble and then add newspapers and gasoline until the blaze got good and popping, and then we'd cook the frogs on it. We were going to camp out. We were going to eat frog legs, but then we got there, and we could only find two bodies. They were pretty smashed up. We looked for Buddy Hopper for an hour, or maybe it was Ribbit Valens, but we never found him, and, in the end, we buried the other two under the tree. My brother made me dig the hole. I had blisters for a week. He just sat there, opening and closing the lighter and talking like a math teacher. Like a cop. He kept telling me, over and over, how there wasn't no way the other one was alive, and listen, he said, a crash like that leaves no man behind.

ELISABETH BLAIR

## Hypochondria

There's a bird caught in my throat. Down at the bottom, to the right, and her neck angles up toward my ear, which hurts when I put headphones on. I can only speak if I give her space. The doctors and nurses laugh when I say, *Do you see me? Do you see my bird?* They tell each other "watch out for her."

But I do have a bird. When I exercise, air sings through my body as if through a drum. Her eye is beneath my chin, and fixes its stare on the setting of my jaw. She hears everything I think and chew.

When she finally goes, I'll be ripped from the inside while the doctors and nurses laugh because I had one life and they'll think  it's funny I lost it.

And the bird will not be caught.
She'll make it pretty far.
Watch out for her.

ELISABETH BLAIR

## Do You Believe in Bigfoot?

I believe in women

and
shoved up against them—
unafraid—
familiar:

men

    —all fists and furs—

I believe these leave

prints

and that we should

    go in search

ELISABETH BLAIR

## From emperor to fly

here, in the landscape
of your death

you speak in lists

fly into windows
smash against screens

                                        you wanted to be
                                        venerable

but you're juvenile
        and pantsed—
        a teenage boy in sweats

someone better photograph this

WOODY WOODGER

## Erk Shaves

—*After* Michiko Dead *by Jack Gilbert*

He manages like the gentle miner who found
a dinosaur bone but doesn't want anyone
else to know. Trans, it's his first time shaving.
He measures carefully the apple-heavy curves of my neck
with his finger. When satisfied, he nuzzles the blade
deeper against my most stubborn stumps,
the ones wish to remove and reseed in his throat. He moves
a cramp slightly towards his thumb
when his wrist starts to tire. His grip is a crane
operated by butterflies raising a boulder. Afterward,
he chisels out my soft cheeks to find
they've grown soft under this eternity. Like the miner,
he marvels at the secret he has earned, but cannot
yet dislodge. To watch him learn manhood
must sometimes be held like a wet orchid petal
is a sooty beauty. Strength using no muscle. In two days
he can again marvel at the soft bone forever
reappearing the mine wall so he can dig on
without ever putting the razor down.

NEIL CLARK

## When I Turned Into a Giraffe...

... my head made holes in the ceiling, then my neck tore strips through the beautiful mansard roof of our perfect imperfect home. I told you I was sorry. I told you if you wanted to go and live somewhere that protected you from the elements, I would understand. You said it was cool, "We can sleep beneath these stars and wake up when the world wakes up."

... my palate regressed, and I started consuming nothing but shrubbery. I pined for the days when adventurous eating was our thing. We had raw bison heart on our honeymoon, kept a replenishment of century eggs in our basement, ate blowfish prepared by trainee sushi chefs. "Don't worry," you said when I presented you with a platter of tree, served three ways, for the third night in a row. "I can branch out with you."

... I grew concerned about your fear of heights. Your heart-rate goes through the roof at the sight of a step ladder. When you mustered the courage to climb up and visit me on top of the ruins I had made, I nuzzled your beating chest. Then we kissed, and you told me you would never come down from this high.

EVE LINN

## Frida Kahlo Writes a Letter to her Monkey, Camito de Guayabal

*after several self-portraits*

only offspring of my body,
no longer whole or fruitful,
scraped to shards, hinged,
nailed with hidden
spikes, corseted to itself,
skin picked out in sutures,

lustful joker–– in your eyes
deep forest grief––your
home, before abduction
by a man with a truck full of
cages––you barked, twisted
tree branches, torqued spine

lover, eater of ripe fruits, caught
despite your wiles, now you twine
coarse furred arms, hook black
hands around my neck

MARÍA LUISA ARROYO

## twins    springfield, ma

1969

the first time that jimagua grew
in her womb    mami still did not know
about the pain of giving birth
to two & losing one    doctor silva
negligent    with the cord
around the second baby's neck

with a few sharp spanks    the first one
took breaths    found his screams

the second one disappeared
in a hospital called mercy

1977

the second time that jimagua grew
in her second month    a life slipped
between her legs

the other one grew ravenously
to 10 pounds    tried to split in two
the small body of his mother

too big    almost 10 months
he did not want to leave the world
of water & sustenance    guaranteed there

doctor silva's hands yanked out the baby
his wail    drowning

NAKUL GROVER

## Objects

She was obsessed with layers. How, on the chair, everyday scarves, pais-ley or otherwise, would begin to pile one atop the other. How thin slices of cheese stacked together. How peels of onions and garlic got amassed upon each other in the kitchen during hasty cooking. Piles of newspaper in the recycle cupboard. The accumulation of memories in layers, stacks, piles. Does an onion know where it comes from? Does every yarn in the golden paisley motif of a scarf remember its origin somewhere in Iran? Could a piece of cheese trace its memories in the family of cows it came from? She looked around her. T-shirt made in Bangladesh. Broomstick from China. Pants from Vietnam. Candles from Cambodia. Does every object remember where it has come from and where it has been? Does a piece of wax know it is a source of light? Things have been everywhere. Inside dingy ship quarters, inside mailboxes and envelopes, thrown around by men and women of different colors. Most things people pack will never be used by them. You cannot make a sheep out of scarves, cannot grow cotton from every yarn, cannot plant a tree from a little block of paper. She tickled the sides of the newspapers to feel the serrated edges, how one machine would have caused the edges to zigzag, how the ink would have kissed the paper with wet ink. All of this to end up in her hands, in a strange apartment. How much history can she trace? How much history does she care to trace?

CARLA PANCIERA

## For Homework, I Told Them to Break Some Rules

I should have seen it coming when they plugged too many kettles in at once. When they brewed tea in class on Fridays. When they scorned the use of sugar. Ignored the warning bell, stayed in the library after hours. Walked one kilometer of a 5K. Wore the t-shirt anyway. Pilfered string beans from the salad bar at Whole Foods. The substitute teacher could not stop them from dancing. When poems moved them, they cheered. Cried. Left the room without asking. Later, they mocked archetypes, especially those representing spring. One weekend, thirsty, adrift, they helped themselves to lemonade and cookies in the lobby of the Hawthorne Hotel. That winter, they hennaed each other with invisible ink, reappeared first in line for grand openings, for concerts on school nights. By choice, they became bad listeners. *We can't possibly be expected to raise our hands.* One teacher sent an anonymous email comparing them to a man who snuck into Yellowstone and was killed by a hot spring. Anonymous except that the girls know who sent it, have memorized his address, share a deep resentment for metaphors not of their making.

ROY BENTLEY

## A Season of Wind from the South

Chance Locke was a man about to break into a smile.
You've seen the old Spencer Tracy movies. That guy

but even shorter and cradling a Dorothy-in-Oz poodle.
We were neighbors. He'd worked for the railroad in PA.

A union man, he loved to talk politics. Declared a dislike
for the neighbor who favored sending troops to Iraq, who

sashayed like John Wayne—*exactly* like the Duke—when
he walked. Chance Locke was happy now. Nevertheless,

not too long after he moved to the Sunshine State, he said
he got ruined-drunk. Drove his car onto some train tracks.

This isn't invented detail, either. No poetic license here.
Chance chuckled at the luck at marrying his high-school

squeeze who put up with him. He defined happiness and
grace as a season of wind from the South and Democrats

in power up in Tallahassee—I loved the description he
dispensed of deflating four tires so they'd accept the rails,

of a Martin County sheriff who pulled him over, asking
what in the name of all the known gods he was doing.

SHIRLEY J. BREWER

## Breathe

Air: entrée and dessert.
Sweet Air. Savory Air.

Each inhalation thrills.
I am greedy for Air.

My sister became a warrior—
an oxygen tank her armor,

her silver camouflage. She died
four days after Christmas,

fighting for one more,
one more breath.

Silent Air. Holy Air.
I sign my name with Air.

*Breathe in*, I tell myself.
Make a fist with Air.

# When Leaves Begin to Die

The radio, on low, played constantly. Muriel lay in her bed listening to Hank Williams wail. She could see her mother in a red flowered apron, bow at the back, turning up the volume. Her favorite was "I'm So Lonesome I Could Cry." Its grievous notes hung on the kitchen wall like creamy white grease.

Forty years later Muriel lay in bed, 2000 miles away and no radio around, hearing those old country tunes, bluesy moans her mother swayed to while the bacon popped. Muriel now understood that her mother was more country than she'd ever admit. Trying to hide that part of her was why she let Emily Post and the collective opinion of the Albertville Junior League women shape her.

Muriel looked at the ornamental apple with its white blossoms and the new avocados in clusters, wondering if she'd ever feel at home in California. Birds of Paradise with orange-flowered combs and purple-green beaks. So different from the pink funnel azaleas she grew up around. She reached around Sarah, snuggled against her, kissed her fur and got out of bed. Already 10 a.m., Muriel had a Zoom meeting at 11 and a Zoom reading at 2. She worried about what her hair looked like, so she washed her face and reached for the Velcro rollers. Old school but it worked.

She once visited Hank Williams' grave in Montgomery, AL. Fans had left guitar picks and pints of whiskey on the emerald Astroturf. Story was that the overzealous continually plucked blades until it was impossible to keep grass growing.

Would anyone ever visit her grave? She knew she would when she came back. Maybe fly there. Always wanted to be a Monarch butterfly. Bright orange veined in black, as close to eternity as stained glass. Wings in flight making the sound of gentle rain. Or maybe crawl there, depending on her karma balance at the end of this journey.

She dampened her hair and separated it into sections. Starting at the end, she wound one section around the roller so the strands curled

down and toward her scalp. She continued rolling until snug against her head. Nine more rollers.

Sarah brushed against her leg, raising goosebumps.

With the last roll, Muriel and Sarah went to the kitchen for treats. Coffee and Biscotti cookies coated in chocolate for Muriel and Feline Greenies, designed like tiny brown fish with tail fins, for Sarah. She opened her iPhone and found Hank on YouTube. As he began to sing, Muriel looked down at Sarah, her tail beating in time.

Muriel could almost smell bacon fat in the air.

JENNIFER BADOT

## Review: *The Minister of Disturbances* by Zeeshan Kahn Pathan

Diode Editions, 2020 ($18.00)

On the title page of Zeeshan Kahn Pathan's astonishing debut collection, *The Minister of Disturbances,* there's a photo collage by the artist Kostis Pavlou: A man's black suit jacket, with crisp white shirt and black tie, is capped with a surveillance camera in place of a head. In the background, the barbed wire of war zones and prisons. This collage has the effect of immediately disturbing us before we've even read the first poem. We are entering a police state. We are being watched.

Then, turning the page, we venture further into the surveilled landscape of the book, where we encounter the first poem, "Ophthalmology," and we are no less disturbed. A doctor cuts into a man's skull while the man is apparently awake:

> He asked the doctor
> Who had been cutting
>
> Into his skull with a scalpel
> If something else might break
>
> Inside the braincase —
> Would it be fair
>
> For the man to press the switch
> Of departure? This early
>
> In the journey to stop
> The flutter of red phoenixes
>
> And the glances of blond daisies
>
> If it would be okay
> To sleep where the children sleep
>
> Where the narrator lives

Outside of the frame.

The doctor did not answer him
But held a scope to the man's eyes

And kept cutting through tissues
Until the blade had reached

The pearl in his brain.

Like this first poem, quoted here in its entirety, with its glorious "flutters of red phoenixes" and "glances of blond daisies," nearly every poem in this collection is situated at the perilous yet luminous edge between life and death.

Whether the camera's — or the poet's — eye is trained on the detritus of late Empire, the colossal losses and grief associated with climate change and mass extinction, extremist violence, or a lover's betrayal, Pathan's tender and exact ministering — like the doctor with scalpel — reaches always for the pearl that is poetry.

In poem after poem beauty (often in the form of flowers) and the violence of the State walk arm in arm, are fused. Flowered landscapes are strewn with bones, the vocabulary of war is conflated with the vocabulary of desire, an alchemy that creates lines like these from "Inside the Northern Cemetery":

The road blistered like the feet of a Syrian refugee.

In the Nile all through the night —
I am hostage to juniper and orange

Do not let butterflies rise from my notebooks!

Sensuality and delight in simultaneity with our violent reality is one of the defining features of Pathan's poetry, and a strong reminder of the possibilities of creativity and imagination as a form of resistance. These poems enact over and over a central question: What poetry is possible in the face of the monolithic mechanizations of the surveillance State where language itself is drenched in blood? "After Hiroshima," Pathan

writes, "it is hard/to listen to music. It is hard to sing a song." Yet, if we are to remain human in a culture of rampant dehumanization, we must try. We must become ministers to our own longing.

For the speaker of many of these poems, the longing is that of exile and dislocation: longing for homeland, for mother tongue. The fact that Pathan is Muslim-American is certainly a headwater for many of the poems, but it is only one. Tiresias presides over this collection — what we choose to see, are forced to see, and how we are complicit or prophetic. And Eros is here too, coming as Eros does, with force, without warning to "Manhattan/Where I can't sleep even one night without you." The book is dazzlingly kaleidoscopic in its perspective, poetic resonances, cultural influences — and in its impulses toward finitude and apocalypse and also toward redemption, which is never arrived at, never guaranteed.

Flowers are central and abound in these pages. The attention given to them is devotional — yet tinctured often with terror, blood or bullets, as in "War:"

> In a winter of withering
> Rose petals and pink clouds —
> Blossom like bullets

In the collection's satiric and absurdist title poem, flowers are stand-ins for human beings. A quintessential bureaucrat, the "Minister of Disturbances" stands before a microphone to offer empty sympathies "on the deaths of a 100,000/flowers mowed down in the garden of Damascus." The Minister then reads from the transcript of the "Official statement from the Ministry of Butchery and Nowhere" to offer more condolences "On the executions of forty-six jasmine bushes/ In Al-Bab." The substitution and glossing that is the language of the State is meant to obscure and confound the facts – yet, in Pathan's hands, those same facts are dramatically amplified.

The speakers in these poems are all "Ministers of Disturbances" of one kind or another. Whether the disturbance happens in the night or in the day, whether the disturbance is butterflies rising from the page of a notebook or blood filling up the "flowerbeds in Guantanamo and Abu Ghraib," there is no peace, no place where the eye of the camera does

not see us, where the ghost of Orwell does not haunt us, where Cupid's arrow will not pierce and wound us. Pathan's poems bravely ask us: How are we to engage with, combat, dance with, speak to, thwart, eradicate, listen to, feel, resist, sing, overthrow, transform and minister to what disturbs us? For Pathan, who in "Treason" writes, "Sappho and Khayyam, yes I believe in them," — the answer is poetry.

And so, when I read in "Lorca, II"

> This is my prayer. The doors of the night
> Have been eaten by termites. I am just beginning,"

I take it to mean that Pathan the poet is just getting started—and for that I'm grateful. I urge you to reach for this book, let it disturb you, allow its tender ministrations to work on your soul.

ROBBIE GAMBLE

Review: ***When My Body Was A Clinched Fist***
**by Enzo Silon Surin**
Black Lawrence Press, 2020 ($16.95)

In the poem "Born to Triggers," which appears early in this daz-
zling debut full-length collection, Enzo Silon Surin recalls reflexively
running from the sound of gunfire as a young child, when his family
encountered a street riot in his native Haiti. He quickly pulled up when
someone yelled, "Don't run, they'll shoot you!":

> You were nine and did not
> know the body was capable
> of such things on its own...//
>
> ...[some] days the body is a clinched fist.
> at other times it is a doorknob
> leading out and, there is no
>
> such thing as a real shortcut
> to the way back home...

How the body reacts to danger and trauma (Run? Freeze? Fight?) is
the central theme coursing through Silon Surin's poems, from his early
childhood in Petion-ville, Haiti, to the harsh and violent street dramas
of the Jamaica, Queens neighborhood where he came of age after his
family emigrated to New York. The "Clinched Fist" of the title pres-
ents in various manifestations through the book: the knot of unresolv-
able anger carried in the gut; the hand as weapon balled and stowed
in a pocket, always at the ready; the hardened presence and attitude
adopted in order to keep all threats at bay. Behind all of these clinched
postures, survival, both physical and emotional, is a constant struggle.
In an epigraph, he quotes Bessel Van Der Kolk, M.D., "These changes
explain why traumatized individuals become hypervigilant to threat at
the expense of spontaneously engaging in their everyday lives."

Now Silon Surin is re-engaging with his younger life in these poems,

exploring how he was able to survive that day-to-day hostility, when some of his friends did not. In a sequence of American sonnets titled "Letter to A Young Fist," he writes

> Before you sign your name on chalk
> outlines, know this: the shape you
> mold your hand to hold a gun is
> the same as to sway a pen, to cup a yawn
> or knot the lace of a doo rag—it's hard
> to ward grief off...

The sonnet in its essence is a love poem, and these are empathetic, cautionary love poems to his fearful, youthful self, rife with tips for survival and hard-won wisdom. It seems the youth must have intuited some of the older poet's perspective, for he has endured.

And what a voice he has nurtured! I am astonished by the language in these pieces; Silon Surin has managed to carry the chatter and rhythms of the mean streets of Queens, but he has wound them into a lofty, often elegiac tonality that treats his subjects with profound respect. Even a scene as tawdry as when he was propositioned for oral sex while running family errands as an innocent boy is conveyed with a certain gravitas:

> ...the days when soon enough you'd be spit back
> onto the same strip of block where twice
> a woman with eyes belonging to that dragged out
>
> and quintessential gaze proffered you an act of
> fellatio for five dollars. You were ten years old
> on an errand to buy milk in a flatigious galaxy
>
> but carried the weight of her bid on all future
> quests to the grocery store, when the concrete
> sparkled like a sky full of stars under your feet.

Beauty coexists with desperation and urban grit. In the aftermath of helplessly witnessing the brutal beatdown of his friend Leon under the

fists and boots of a merciless posse, he finds himself still "under the glaze of a perpetual and beautiful, beautiful sun," an image that recurs in succeeding poems, the sun always beautiful and illuminating while glazing the stark and sometimes deadly contours of the neighborhood.

Silon Surin's command of craft is remarkable. His word choices are precise and surprising: "jejune fists," "the heart is a purpling bass drum filled with liquid, and grief," "the myopic pool of loiters." The sonnets are lyrical and compact, an utterly fresh take on the form. Two poems, "High School English" and "High's Cool English" appear several pages apart, the latter an inversion of the former, beginning with its last line and returning to the first to scribe a completely altered trajectory of language.

After a thorough exploration of his own physical and psychic relationship with violence and trauma, after poignant elegies for his friend Frankie who was stabbed to death, and a litany of others who were felled in their youth, Silon Surin arrives in the present day with his final piece, a prose poem in stanzas, "When the Body Returns as A One-Hundred-Year-Old Fist." He describes a moment with his four-year-old son, who looks out across their backyard at a century-old poplar tree and declares "daddy, the tree's pointing at me." The moment is a catalyst for the poet to consider the bruised chronology of his years, of emigration and shifting family arrangements, births, deaths, world events, the cycles of loss and trauma and small clawed-back victories. In the end, witnessing this interaction between ancient tree and young son, he warily embodies "a new definition of optimism." This is an essential, indelible poetry collection.

CHRISTINE JONES

Review: ***The Deepest Part of Dark***
**by Anne Elezabeth Pluto**
Unlikely Books, 2020

In her most recent full-length collection of poetry, Anne Elezabeth Pluto brings her reader on a divine spiritual quest. One, that at times, might feel as if travelling the concentric depths of Dante's *Divine Comedy*. Allegorically, *Divine Comedy* represents the soul's journey toward God, a journey through the three realms of the dead. *The Deepest Part of Dark* feels very much like such a journey as Pluto's poems explore her soul through love, loss, and faith.

It is fitting that Pluto chose to divide this book into seven sections given the symbolism of the number seven within Christianity. There are the Seven Joys and Seven Sorrows of Virgin Mary, the Seven Corporal and Seven Spiritual Acts of Mercy, the Seven Virtues, the Seven Deadly Sins, also the Seven Sacraments. While the seven sections do not necessarily correspond with the seven sacraments, the first section does have elements of baptism, a rebirth of sorts, as the speaker relives her childhood and discovers, through the loss of her mother, the pleasures and pain of becoming who we are. This discovery involves grappling with her desire to know the underworld. She opens the book with "The River Styx":

> …I wait for you
> each night—I pray you may appear
> and tell me the story of how it was
> to cross over.

Pluto is adept at foraging her dreams, a technique she translates as craft for her poetry. Many of the poems in this collection involve dreamscapes where the speaker is trusting of the unconscious knowing, begging to find solace for her sorrows, such as in the very next poem "The Fog" which recounts:

> …I am
> dreaming, standing—parting the

curtains to see the dove gray fog lift
praying for sun—and the world
to roll over.

Death, and the speaker's fascination with it is presented in a direct and unfrightening way. In the poem, "Funeral", she invites the reader to open to the possibility of death as something beautiful:

...your hands, hold me there
while I drain perfect
finally into Death,
lay me down
an embroidered pillow at my head...

There is an ethereal quality to the speaker's grief, yet all the while there is still a devotion to the earth:

...and cover my face
piece me to the earth
eternal, alone
in the grave
in the darkness...

This language provides a grounding foundation for the reader. True to the collection's title, there are many references to darkness, but Pluto remembers to include shades of light, which is another captivating force that steadies the reader. The poem, "True Time" reveals a cemetery blossoming pink against a dark loam. Elsewhere, there are birds, stars, honey locust trees, wine *white and crisp*, and caterpillars "hung like earrings in the twilight."

Several of the poems found in section two have been said to be reminiscent of Joseph Brodsky's Nativity poems. The poem titles alone reveal a similar devotion to Russian Orthodoxy and their scenes and settings bring attention to a waking consciousness that Brodsky was also inspired by. It was not surprising to learn that Pluto translated Brodsky while she was in college. Beyond Brodsky however, there is a feminine quality that expresses Pluto's own sense of reverence and humility. Such as in "Crucifixion:

I'll wait
like Mary
like the Mother of God
and Mary
the Magdalene
 and the other one
whose name I
cannot remember
until
you rise
and walk
from the grave

Midway through *The Deepest Part of Dark*, the poem considered to be one of the most transgressive of the volume, "Unnatural Acts", unveils Pluto as storyteller, as ghost seer, as child, now woman, who writes with a meditative clairvoyance, again visiting her fascination with the underworld.

Great, great, great
grandfather alone I pull you—
cold, bones to my coat
kiss your teeth, breathe
air, frost into your suit
it swells, flesh
of the man who made
the man who made
the man who made
the woman who gave
the child a heart
to see the dead
through dreams

Here, she relies on her mystical prowess to imagine the unearthing of her great, great, great grandfather in winter who lies in *layers of Russian*. She provides vivid details of breaking her nails digging through ice and snow, scratching at the pine box. She breathes life into death. This is a poet who is and who isn't afraid. She continues to approach the

divine but refuses to be led by simple affirmation. She's fully aware that a "missed train" or "running out of milk" means nothing and pushes beyond the quotidian to explore the deepest parts of self. Section four opens with "Coffee Break with Couplets" which reflects upon the poem she was composing in her dreams when she was young with "hard dark hair" and "couldn't imagine that time would be presented in envelopes."

A longing fills the pages of section five. A wanting for the knowledge of what it means to love, to suffer, and "to be a man." Here, and throughout the book, Pluto deftly employs the natural world and familiar religious icons to transport the reader. In "Life Preserver", the speaker sits "under the blessed/ Mother—in her orthodox red and gold." Use of such associative images provides relief allowing the reader to stay with her as she continues to broach the topics of loss and love. It is in this section where we find the title poem of this collection about a first love who the speaker recently learns has died. This is the encore poem you will read again and again. Better yet if you can hear Pluto read aloud, for these poems fill the ear with a rich resonance.

Pluto's broad scholarship of literature infuses the text most notably in section six where she writes after Garcia Lorca and Shakespeare and includes poems titled Dido, also OZ. Delightfully, in "Portia", her use of tone and voice reflect a Shakespearean play.

Just as Pluto opens the book with poems about her mother, she fittingly bookends it with poems about her father. The child, woman, dreamer, ghost-seer, and storyteller are sandwiched in between. Emotions range from intrigue and fascination to courage and confidence, but mostly it is a soulful sorrow that embodies this transcendent collection and hovers like the ghosts it invokes. Graciously, readers will return to these poems with their own questions, divining their own quest to discover the deepest parts of their soul.

MARK JEDNASZEWSKI

Review: *Time. Wow.* by Neil Clark
Back Patio Press, 2020 ($12.00)

When I learned the universe was going to give us a Neil Clark flash collection, I pressed the preorder button faster than a packet of photons screaming from the Sun. I first discovered Clark's writing through his #vss365 tweets, which are tweet-sized pieces arising from a daily, single-word prompt. The results of his participation in the game are always smart and beautiful, often involving clever wordplay or a satisfying ending. What I connected with most—aside from the precise language and his industry to generate unique material—was the subject matter, the microscopic capsules almost always smacking of galaxies, nebulae, and stardust. As a lover of the short form and of all things cosmic, he quickly became one of my favorite new writers.

The stories in Clark's debut collection, *Time. Wow.*, have an impressive luster, as if they had been examined from every angle to properly execute the perfect diction, concision, and rhythm. Each story may leave you deep in thought or on the verge of an existential crisis—the good kind—where you are urged to contemplate what is important. The characters are relatable that way, making it impossible not to connect with them and engage immediately with their feelings (not an easy thing to do in such few words). The characters in his stories are introspective and compassionate, dealing with the mundane tasks we are all familiar with. But Clark gives the stories a fresh flavor that blends the banality with the celestial. For instance, in his micro "Sleeping with the Fishes," a tenant is responsible for the loss of their bed after a black hole appears in the flat. As revenge on the landlord, the tenant hides a dead fish in the black hole to stink up the place for an eternity. Clark often introduces these mind-bending wrinkles into his work, giving it a fresh voice.

Since I started editing flash for Lily, I have learned a lot about what works and what doesn't. I find that many other editors agree with my pet peeves, and it informs my own writing on what not to do. The thing is, I don't like to say "never." A very talented writer friend of mine wrote several stories that involved scenes that you're not supposed to write, because she was interested in the challenge of writing a wedding scene,

for instance, work when it usually does not. I like writers who know how to bend the rules for success, because they understand the rules, and the product is often dazzling. It seems to me that one of flash's no-no's is to end with a twist or a punchline. Flash that wraps up too neatly in the end leaves nothing to resonate with the reader. However, there are always exceptions to the rule. Clark's work consistently makes exceptions to the wrapped-up "rule" so often and so cleverly that I am always left in awe. The collection is balanced with both these types of spherical stories and with tesseracts: stories so open-ended—yet complete—that they leave you lost in wonder, haunted by them weeks later.

Another astonishing aspect of the collection is Clark's bravery with experimental form. In the story "+0," the narrator is alone at a wedding reception. The decisions the character makes, and their increasingly frantic voice, illustrate a raw rendering of what social anxiety is like. An expert on social anxiety could describe the complex sensation to a person who has never experienced it, yet never get the meaning across. But with brevity, Clark connects the reader with that feeling successfully in this piece.

When you order your copy of *Time. Wow.*, prepare to experience time dilation and spaghettification as you dive into Neil Clark's cosmic observations. Physicists warn that the tidal forces will destroy you during your journey into a black hole, but I've been through the wormhole, and I suggest you take the ride too. I promise you'll never forget it.

SARAH WALKER

## Review: *48 Blitz* by **Brett Biebel**
Split/Lip Press, 2020 ($16.00)

When I read the book jacket of Brett Biebel's *48 Blitz*, published in December by Split/Lip Press, I knew I was all in before inhaling a single story. The stories that make up *48 Blitz* are short and strong. They show that small and rural towns, where Biebel's often neglected yet loud and original characters live, are places many people should not turn away from, but hope to discover.

A once high school football star who does not wish to be remembered for his years of stardom, a beloved man on death row, multiple born-again-Christians hoping to convert their new companions, are a few of the memorable characters that live within *48 Blitz*. The characters and their stories take many different turns, never allowing the reader to predict the outcome or their fates. Yet a voice, strangely comforting and close, rides through many of the stories. It's a familiar voice. It's a curious and nonjudgmental narrator, perhaps someone the author hopes the reader will be, too. And it's in this magical balance of the spontaneous, familiar, and absurd that boils a new excitement with the ending and beginning of each story.

Commendable, too, is the actual narrative—the patience and language Biebel uses to tell each story, no matter the length. He's not afraid to show. One of my favorite stories is "Platte River Love Song." Two long-time friends go fishing after a much anticipated local election, bringing two girls with them, although the narrator cannot remember where they had met them. The almost two-page story is mostly scene, with imagery and characterization so vivid I had to read these lines again and again just to make them live longer: "You could hear water hitting the boat, and every time we caught a sunny we threw it into the Dairy Queen bag, on top of about four cans of beer. It would make a sound like a hockey puck, or else gravel spraying your hubcaps. The girls thought we should let them go, but Adler said if you do it for one, you got to do it for all, and they pretended to understand." On the contrary, Biebel is not afraid to tell. His characters often give the reader the lowdown, allowing an easy understanding of their predicament. This straight-forward telling is in another favorite of mine, "Happy Fish Bait

n' Tackle," where the narrator goes on a first date with a guy she met online. The opening lines rope the reader in, not only to captivate, but to include us in her finite experience: "...Our first date was supposed to be at the Mulberry's down State 19, but at the last minute he called and said a friend of his had this softball team short players. He said they had a particular need for women, and I don't know why, but maybe I liked his picture. Maybe I knew word traveled and wouldn't Kev be jealous seeing his little Pop-Tart move on so fast."

The 48 stories are small and dazzling gems, meant to be considered separately, but also part of a whole, which happens to be a place the characters wear on their backs and in their hearts. If time allows, some readers and writers I know like to consume books in one sitting, understanding the larger idea or picture the author might have been trying to accomplish. But I recommend taking your time with Biebel's collection. Take tiny bites, let the stories and voices marinate before reading the next. You won't regret it.

ANDY SMART

## Review: **Randall Horton's {#289-128}:Poems**

University Press of Kentucky, 2020. ($20.00)

While there is no debating that the pieces in Randall Horton's latest book are poems, it may well be an oversimplification to call {#289-128} a poetry collection; Horton's book could also justifiably be classified as verse nonfiction (not wholly dissimilar to his memoir, *Hook*) or a series of lyrical short stories—fictitious only in that the poems often address the fallacy of justice in America, the concocted definitions of innocence and guilt, and the speculative lives of Americans on streets and subways. Above all, the poet and the speakers in the poems confront the myriad systems of confinement, especially among black men, which often go unmentioned in this country.

Regardless of classification, however, there is undeniable authenticity and clarity in Horton's newest release. Consider the following from ".Or. This *Malus* Thing Never to Be Confused with Justice":

'nothing symbolic. okay. dark is dark—/cage is cage . . ./in the literal . . ./nothing symbolic here'.

Horton offers no apologies for the content of these poems, just as the justice system of which he writes offers no apologies for the contents of America's prisons. The poet, then, not only offers a biting social commentary but also blunt reflections on selfhood, language, and the othering effect of imprisonment. From the same poem:

'there are no allegories to hide behind./. . . to contain utter disbelief. of the visible'.

The poet confronts the surreal fact that an inmate—or a convict, a prisoner, a piece of state property—while still confined within his body, is transmuted into something else. For instance, Horton devotes an entire poem to the loss of family during incarceration. In "How to Become the Invisible Man", he writes:'no one will visit today/. . . friends dissipated first/. . . girlfriend never wrote/. . . family blocked every collect call/ . . . believe a whole body can disappear'.

The above examples illustrate a pervasive element in {#289-128}: juxtaposed states of being. One poem nods to the unbelievable nature of the observable, while another is forced to acknowledge the vestigial death brought by being locked up. These juxtapositions are a vehicle for, to this reviewer, the most prominent craft function in the

book—alienation.

While Horton's other works are seldom linear—and, in the main, this collection isn't either—in some ways the new book departs from the poet's norms. Horton begins his book-length illustration of a divided society in the first poem, "Animals". The epigraph:"'The only thing less than a nigga is a prisoner'—Rojai Fentress, August Correctional Facility" Beginning with this thought, Horton explodes the fictitious unity of the United States, providing, instead of a picture of a cohesive demographic—black folks, prisoners, men—an increasingly fractured individualism which hinges on degrees of alienation. First, blacks from the rest of America, then prisoners from black folks. As the collection progresses, Horton quickly extrapolates and expounds on his own alienation not only from the American "justice" system—as illustrated in the second poem of the book ": Arrest Warrant" but from other prisoners. Horton's act of standout culminates in ": Sorry This Not That Poem". From that poem: ". . . forgive state poet {#289-128}/for not scribbling illusions/. . . as if timeless hell//could be captured by stanzas/alliteration or slant rhyme".

Incarceration not only chains the body, secrets it away from the allegedly-free world, but also chains the mind, the soul, the essence of the imprisoned; for the speakers in Horton's poems, who are by turns unapologetically autobiographical and vaguely universal, poetry is both an alienation from the masses of other numbered inmates, but also a strange liberty of words. In the opening poem of the second section, ": On Reflection", Horton begins to explore this strangeness, the muffled rebellions and screamed desperations of language in an eight-by-ten cell:

> "because a box is a box humans are cultivated/into said box without choice or explanation . . .     /note: the box is not universal/ nor the universal. whatever hope of otherworldliness lies in the box itself/. . . precious as flickering light".

The life of the mind, as Patricia Hampl calls the interiority brought on by stillness, is estranged from the external world and, therefore, somehow magically more in tune therewith. Horton and his speakers

are, to quote Lord Finesse, "Hip 2 Da Game" as evidenced by such observations as:

> "darkness is the original concept of all things human".

As opposed to a myopic bleakness, Horton's prison poems maintain a hope that is by turns stupid, noble, or half-dead. But it is this hope which, ultimately, alienates the prison environment and its effect on the poet—and his poems—which rings triumphant in the final section of {#289-128}

It's not that simple, of course. There is hope in these poems, but there are also generations of accusations and reckonings left unaddressed by the forces outside the frame.

What Horton points to in these poems, irrespective of any post-facto relief felt by readers who know, obviously, the poet is alive and well in New Jersey, is the very real targeting of a whole demographic. Beginning with blackness, equaling marginalization, moving on to incarceration, resulting in institutionalization, the pinnacle being extermination if not of the body, of the [self]. Prison did not break Dr. Randall Horton, the poet formerly and occasionally doing business as {#289-128}. But the brokenness of others is of equal or exceeding concern to the poet as he brings to life the prison experience, *en media res* and afterward, "not with breath//but with breath's imagination".

Horton's newest book brings together a black man summoned to a courtroom in Maryland, a black man spitting lyrical images into the wind outside the window of Roxbury Correctional, and a black man penning the strength of all his accrued insights on the New York City subway such as the victorious, epiphanic jussive: "let's call {#289-128} human".

Yes. Let us.

Horton brings readers to the end of a masterful collection with the following prophecy from ": After Ruin":

> "beauty after ruin lingers on the *event* horizon: infinity plus one, a
> new monin' . . . climaxing   into a new way of looking--: in. ruin

does this and is perhaps evermore tied to the beautiful . . . You can't just *be*, so you become . . . again and again . . . a repeated action".

This book cannot just be, and therefore continues to become and rebecome. No matter how a reader comes to it or walks off from it, Randall Horton's latest poetry will chain itself with wings and a shank wrapped in toilet paper to the reader's memory and imagination. And make them grateful. This is Horton at his finest: he locks you up and throws in the key. Do with it as you will.

EILEEN CLEARY

## Review: *Come-Hither Honeycomb* by Erin Belieu
Copper Canyon Press 2021 ($16.00)

Erin Belieu's fifth poetry collection, *Come-Hither Honeycomb,* offers read-
ers her signature wit, narrative energy, and a life-time supply of finely
hewn lyrical prowess. On the cover, Whiskey Radish captures a wom-
an's refusal to break apart despite trauma's wear and tear. The disarm-
ingly spare drawing of a frayed and tangled knot puts me in mind of
how we are bound to by "durable strings" while pulling away from our
histories.

The first poem, "Instructions for the Hostage," is a villanelle that intro-
duces the overall sting of what entraps us, and repeatedly adds new
insight into how we just might be a key loop in that bind.

> You must accept that the door is never shut
> You've always been free to leave at any time,
> though the hostage will remain no matter what.

This book spirits a "Jesus-eyed" vulnerability in its violet heart. It
insists that "If we're lucky it's always a terrible time/ to die." This is
made ever more poignant because of the poet's unflinching admission
that "some of us/are chum," amid life's "terror bursting/ skyward all
grassy spangle and screech."

The poet understands that joy and sadness have their cycles as drawn
in the poem, "In Airports."

> It was the season for
> weeping  in airports  for walking
>
> and bleeding  in airports—

In poem after poem the poet enters the scenery and engages in brilliant
curiosity and world-building observations. This causes the passages to
be textured and muscular as the poetry not only reflects each scene but
transforms it. Fire ants build "small volcanoes/ to the door," and we
are put in mind of invisible work, challenges of uphill climbs, and the
explosion of danger and nature that awaits within our reaches.

This book is steeped in the quotidian of malls, doctor's offices, pools, and Sunday Mass. Intelligence and wry humor are in conversation with the speaker's inner reckonings of past abuse and life's brutality. They are equally conversant with her raw and unbridled love for her son and a fierce insistence on not allowing her inner tenderness to craze or crack. From "Dum Spiro Spero":

> Today I watched the other birds
> who lived this winter
>
> peppering our tulip tree. The buds'
> tough seams began to crack.
>
> Ordinary. No sign to read, I know.
> But while we breathe, we hope.

I urge you to read this *Come Hither Honeycomb* and challenge you not to feel, if only for the length of this collection, as if your own inner storm hasn't wandered off "to spook some other/ neighborhood" as you lose yourself in its power.

ALIX PHAM

# Review: *All That Wasted Fruit* by Arminé Iknadossian
Main Street Rag, 2018 ($14.00)

"For whom is the conception?" the women ask in the opening poem by Arminé Iknadossian in her raw and revelatory book, *All That Wasted Fruit*. Despite being left behind by men, these women embody life, consisting of births and creating ideas and concepts through death and the ending of everything. Iknadossian's poems pose questions but do not provide quaint, straightforward answers. These poems interrogate identities or perceptions of female power (or lack thereof), and the collective status women have held throughout history.

This book is organized into six archetypes of women: Lover, Warrior, Queen Mother, Goddess, Priestess, and Wise Woman. Iknadossian leads the reader to explore reality with dreams, historical facts with what-ifs, and the immediate present to illustrate and redefine what it looks like and means to be a woman. Although the poems are organized in six archetypes, they are not hierarchical and do not imply that a woman can only be one or a few. Iknadossian's speakers embody all of these aspects and portray a combination of them depending on the circumstances.

The title of the book, *All That Wasted Fruit*, comes from the poem "Father After Surgery," The speaker's father gazes out of the hospital's window and sees a mulberry tree. He utters: "All that wasted fruit..." These wise words may be an epiphany gained from being closer to death or the culmination of life experiences that imprint missed opportunities, mistakes, and regrets made when we are young. Perhaps this profound observation is made more complicated for women because of male-dominated belief systems, religious doctrines, and socioeconomic factors that have caused us to waste the fruits of our minds, hands, and lives. Perhaps because she is a child of Beirut, Lebanon, forced to immigrate to the United States because of the civil war, Iknadossian's speakers understand these wasted fruits far too keenly.

Despite this trauma, the father, who breathes this realization to his daughter, fails to note one of the most critical relationships wasting next to him: his daughter. How do we reconcile this belated wisdom when, as the poem "War-torn" points out, "all these fallen apples we

have eaten / in this tired age of our own curiosity" have not ended wars among people, country, or families?

Throughout this collection, especially in Lover, Iknadossian exposes age-old conceits about women, revealing sufferings and sorrows, loves and lies, truths and terrors women have endured and survived with resilience, courage, and wisdom. In "Rose of Sharon," a woman dares to «stick(s) her red tongue out to God / fed up with his promises and tinted glasses,» realizing her lover is a «filthy beast» and that she deserves better. She «choose[s] when and how [she] will make love for the first time / and what shade of red the sky will be when it happens» in «The First Time.»

As Warriors, women are born fighters, gilded in blood from infancy to adulthood, and battlefields can be places other than trenches. " The poem "War-torn" challenges us to "Think of a room where you have not bled in." In "Ossuary," the speaker states that the human body «is stubborn/like hair that refuses to part down the middle.» This physicality strengthens the warrior women to endure, survive and overcome struggles.

In "Pre-History," we listen to a Queen Mother share the lessons of her life and address the question as to who she is: "an inconvenient queen" who defies kneeling and giving up the power of her tongue. Iknadossian's speaker is aware that our voices have been silenced for too long, that we have paid a high price, and the time of reckoning is now. In her poem, "The Locust," the speaker is "a woman / with hunger and pride [who] rather hide / behind her words than give them up / would much rather live among the poison wheat."

In "Branded," the speaker "decide[s] what heaven will look like." It's because the speaker "understands the insistent calling" (H.D.) that is "like a feral cat with an empty stomach." This deep hunger drives her to continually search, to birth children of flesh or words like the poem "Anahit in a New Millennium." In verse, Anahit, an ancient Armenian goddess of fertility, is reimagined as a modern woman who eschews the trappings of her time, refusing to "buy a telephone or a television set." Anahit chooses instead to write about "avocado trees that carry babies in viscous wombs" because she never had children. The reader learns birth and children can come in other forms: literary as well as physical.

The priestess in "Tattooed Lady" reminds us women possess the innate power that «reaches for a holy hand» when «the fallen fruit gathered from the field is empty of gossip.»

Finally, in "Reckoning," Iknadossian illustrates the true wisdom of a Wise Woman: "Grant me the words to risk everything." Being female means to risk words like "the color of skin after the slap," "with names like borrowed clothes," and "unbound and spread across the white pillow" so that we can "return(ed) whole again like uneaten fruit." This is the reckoning of the self to the self, an accounting to men and the world.

And Iknadossian dares to risk everything that truly matters: her nails, her hair, her uterus, her religion, her country, her father, her mother. All are placed upon the altar of her heart, spirit, and life and given to us: her sisters, nieces, mothers, grandmothers, aunts, and children. Her poems are rich in language, imagery, and mythology, delving into the feminine psyche and curating its treasures. *All That Wasted Fruit* is the woman›s voice in her myriad forms and sings authenticity and courage, burning the limitations of male-dominated society and history. It illuminates a woman as a lover, warrior, queen mother, goddess, priestess, and as wisdom. It reminds us of who we are, our potentials for destruction and salvation, our nature as mortals and gods vying to not waste our fruit.

KALI LIGHTFOOT

## Review: *Eat the Damn Pie* by Linda Spolidoro
YesNo Press, 2019 ($12.00)

A journey through Linda Spolidoro's debut collection of poems begins at the cover, created by Clay Ventre, at first glance an abstract of lines in blood red of different widths and weights. But when the book is held at a slant end-to-end, the lines resolve into *EAT THE DAMN PIE*. At the end of the book, there is a short biographical statement that gives the reader a few clues to the background of the poet—jobs held, education, poems published, family—and includes flashes of wit: "… unofficial expert on Russian Literature," "…two remaining cats, and a garden full of their many victims (the cats' victims that is)"

And here is a bio statement from the website of *The Incessant Pipe*: "Linda Spolidoro is a writer, poet, melancholic, and dedicated yogi. After years of questionable decision making, she found the yogic path, gave up smoking, drinking, swearing, and sex. Well, smoking." (https://incessantpipe.wordpress.com/2018/04/27/eat-the-damn-pie/)

Both bios were written by Spolidoro—that is how the publishing world works—and both, combined with the cover, are a good introduction to the voice that animates the poems. These are not poems filled with ethereal, spiritual beauty and calm that you might expect from the stereotypic yoga teacher. In fact, they are quite the opposite—raw, earthy, and honest poems filled with grit and wit. They were made by a body enlivened by spirit—the animating force within all living beings.

The speaker's general attitude toward the religious notions of spirit and spiritual, especially from the Catholicism she was raised with, come through in poems like "confession:"

    …a side-eyed middle-man
he never looks directly at you
not to spare you any discomfort
but to reinforce the power
of peripheral vision

    he knows guilt only hurts from the inside out
while humiliation can be carried
like a sick and panting dog across
the shoulders…

The title poem, "eat the damn pie or drop the fork" also seems to consider guilt and humiliation of an unnamed "you" that might be the speaker's mother, who figures in other poems, or even aspects of the speaker herself. The poem's form breaks the pattern of shorter lines found in the poems that precede it, but introduces (with slashes) a new kind of jagged rhythm that is a good match to the content:

> why are you sitting in that chair opened palms to your forehead /
> don't you know there are locomotives on your shoes / you
> hobbled the track all by yourself / pulled it up tie by tie

> then sat back flipping pennies into the air / a field of wildflowers
> springs up around you / but you full as a bloated tick / spit the
> weakest equivocations / from between your teeth...

The book is the work of a woman of substance, a woman to be reckoned with, and beyond that she is also a poet with a gift for syntax, an ear for the rhythm of a sentence and line such that punctuation is largely unnecessary. One might be halfway through the collection before realizing that the writer hasn't used any, except for an occasional em-dash, and the slashes in the poem above. Any more would have been simply ornamentation. Her clarity of meaning is achieved by spaces and breaks, not punctuation marks. As a result, this is a great collection to read aloud.

Spolidoro writes fiercely, with a deep and rather fatalistic love of beauty that might come from her love of Russian literature. The final poem, "The Inheritor," begins with the line "He confessed that he had never loved beautiful women...," and ends with this stanza, the last words in the book:

> She would eventually slip away and he'd be left
> with ashes in a coffee can with the torn label still attached
> and his heart too, would stop beating its doddering thump—
> and all the beauty that never existed would be reduced to a prayer
> he'd recite at bedtime as he climbed into her body like a coffin
> pulling on top of his own, her beautiful ugly bones.

PETER VALENTE

Review: **The grass sings its deep song: On Gloria Monaghan's** *Hydrangea*
Kelsay Books, 2020 ($16.00)

One of the major problems with traditional science is that it approaches the environment as a static, objectified "thing" that we, as observers, can distance ourselves from and study as if we are not part of it, or an influence upon it, or influenced by it. All major Neolithic religions have the view that man is the center of the universe and not an essential part of the complex nature of his environment. Animals embody this instinctively. There is no concept of separation; there is only embodied wisdom in action. Thus, watching an animal move in its natural environment is like pure yoga. The most profound experiences of yoga occur in this kind of space, with no distinction between the "I" and the "thou,"; this is when one fully surrenders oneself to the wisdom embodied in the organic, and when the intuitive body and the breath simply flows in this space unhindered and free from the separation that causes suffering. This is the kind of animistic space in which the poems of Gloria Monaghan's *Hydrangea* manifest themselves. In "September," she writes:

> I have spent the day like the sitting seagulls.
> My question being, how do they know to sit together
> facing the same way, sitting the same way,
> their heads turned at the same angle?
> Is it for the sake of one?
>
> Are they following their inner heartbeat?
>
> Do each of us reflect the other
> white breast facing forward?
> Impeccable boat across the waves,
> I cling to your bow.

Watching processes in the natural world, as well as the behavior of animals, can teach us about ourselves, not only by mirroring our own

behavior in an animistic sense, but also by making us aware of the extent to which we are apart, clinging to that tenuous connection, during moments of transcendence, and suffering when we are left unmoored in the world, afloat on the waves. When one ignores or forgets that one is in a symbiotic relationship with corporeal and participatory modes of experience, the unconscious and intuitive sense of reality becomes dysfunctional, and destroys the corporeal and sensuous world that sustains it.

One of the lessons such a view of the world teaches us is stillness:

> A praying mantis came into the living room
> And stared at my daughter and me;
> Huge soft eyes so kind
> What to do about that?
>
> It was teaching me about stillness.
> It was a hard lesson.
> I can't let go of summer.

Poet Zhou Xuanjing, writes that, "The secret of the receptive /Must be sought in stillness/ Within stillness there remains /The potential for action." In the present world it is so difficult to remain still and focused. As the World recedes, we are given in its place a seamless digital copy; a simulacrum; where Life was once discontinuous, boring, joyful, and sad, we now have the eternal hope for a kind of digital paradise, where there is no loss, where one is constantly preoccupied, obsessed, but with a sense of mourning, a sense of something missing, a lack. Baudrillard writes, in *Consumer* Society, "You have to try everything, for consumerist man is haunted by the fear of 'missing' something, some form of enjoyment or other. It is no longer desire, or even 'taste,' or a specific inclination that are at stake, but a generalized curiosity, driven by a vague sense of unease." The hours pass and pass with no sense of duration; it's as though no time has passed at all. As a result, we've also lost touch with the mysteries of our inner self that are revealed during meditation and during the practice of being still.

To Listen can reconfigure one's sense of sound. Not music for mind as much as for body: the dance. The sense of mystery that sound holds, but

not revelation in any conventional sense. Messages in an alien tongue. Vividly present, clearing the perceptive window:

Each bird sings from the hedge his
Sad sweet song that does not require

a backstory of time and place.
Do these sparrows somehow lift into their hearts

a past dream of young love,
or do they lift with them chance, into the billowing sky?

small beating hearts against the terrible whiteness?

In "Plant Life," Monaghan writes, "There is the buzzing of crickets in the thick green / and the dragonfly whirls. / Blue light shines off him - // undone, as we all are, by love." The sound of the crickets and the whirling of the dragonfly resonate deep within her, signifying love's effect. The sound has no prehistory. It exists *now*. John Cage taught us that ambient noise is a kind of music. Listen to the birds. Tune into their frequencies; slowed down you can actually hear birds producing more than one note at the same time naturally. When this is done with a monophonic instrument, like a soprano saxaphone, the technique is called multiphonics. There is music everywhere in nature.

One breathes without thinking about it. But breath control, or pranayama, is the fourth of Patanjali's eight limbs of yoga. Scientific research shows us that paying attention to your breath and learning how to manipulate it is one of the most effective ways to lower stress levels that occur every day and to improve a number of health factors that range from one's mood to one's metabolism. In "Gifts" Managhan writes about the relation between breath and language:

On the computer screen
words come before movements

negative space the interbreath of our design
our lives before and after

that sweet space.

She speaks of that "sweet space" between breaths, a negative space, that is "our design"; "words come before movements." These are the words, the sounds, with no "backstory," no prehistory; I think of them as the inner voice that one listens to in meditation; it comes from an intuitive and sensuous space. From stillness not movement. In the yoga scriptures, Pranayama is described as the various ways of holding the breath. In one of the most best known scriptures, the Yoga Sutra of Patanjali, it says: "Pranayama is cessation of the movement of inhalation and exhalation" and "Thus the covering of the light is dissolved and the mind is fit for concentration." In certain exercises you either inhale or exhale, while completely and hold the breath. This is the "negative space" in the poem that contains unity before the separation of the breathes.

These are also poems of longing and desire: "The iris of the cat expands / and decreases with wonder and interest, such is the marker of the body, / which informs the mind of intention and desire." There is no separation between the human and the animal. The iris of the cat's eye dilating or contracting is like the human that intends things and desires them. It is a matter of dilating to let the light in or contracting when there is too much light. This can be understood as modulating the understanding. She opens this poem, "Meditation Three" with the lines "I was in the mind of the snow / I was in the mind of the squirrel." When the ego is blinded, or when one is in actual danger, another voice, from deep within oneself, "tells you / everything is going to be all right." But there also moments of wonder at the body itself, it's corporeality, a kind of ecstatic moment of illumination and love:

> I am grateful for the pink teacup roses and stamina of the tiger lilies.
> I am grateful for my fingers, hair, and body. The way my arms spread and come back to me in the motion of a breaststroke.
>
> In the garden people prepare their lawns.
> Still the birds mingle with each other
> and the grass sings its deep song.

I am reminded of George Eliot's lines: "If we had a keen vision and feeling of all ordinary human life, it would be like hearing the grass grow and the squirrel's heart beat and we should die of that roar which

lies on the other side of silence." The limbs of the body are aligned with the natural world, symbiotic. Furthermore, she writes, "the new purple perennial / lavender and the white hydrangea / promise we will have another summer of deep love." The hydrangea is in symbiotic relation to feelings of deep love.

Hydrangea is derived from the Greek word meaning "water vessel," because of the shape of its seed capsules. According to a Japanese legend, a Japanese emperor gave this flower to the family of the girl he loved to show how much he cared about her and to ask her to forgive him for his neglect of her while on business trips. Thus, the hydrangea became associated with genuine emotion, or gratitude for understanding, as well as for accepting apologies. The hydrangea has numerous meanings, ranging from genuine emotion and gratitude to boastfulness. Each of these meanings is a result of different cultural beliefs and stories. Victorians, for example, believed hydrangeas to be a negative plant and used it to symbolize bragging or vanity. This was because they produced magnificent flowers, but very few seeds. They were also given to the beloved who turned down the interest of a lover as signs that the beloved was cold or frigid. In "Pleasure is never at home," Monaghan alludes to problems with a lover at home, beginning the poem with the line, "All things are spoiled by use." She continues:

> I created my prison like Ariadne
> to free myself,
> to elevate sadness,
> to imagine flight
> in those careful steps I took away from you like a
>
> shadow underneath the sleep
> of your closed eye unknowing,
> as I separate myself from you
> into the glittering light of the kitchen window
> pleasure is never at home.

She suggests another memory of love lost in the poem, "The Bed": "I forgot the weight of your body / there is no wind to blow the white curtain. // I have forgotten your voice / the summer is ending." The

summer is time of hope that is ending; the loneliness of winter is coming. In "Betrayal of the Heart," she writes, "You left me here alone – to be fair, I got married." The poem suggests the complications of love that arise when you're a teenager; and you think you have all the time in the world to sort out your feelings and you imagine, wrongly, that the beloved will wait for you. In "Corazón (Narcissus)," she suggests a relationship that failed because of a betrayal and her own part in this: "I put your letter in my pocket and it stirs my heart into / remorse for all those I hurt, and now I am like them; a reflection in the eye of a small freckled bird. / I dream of you." The hydrangea as a symbol for the beloved coldness to a lover's advances is given a positive spin in the poem, "Penstemon," which concerns the virginity of young girls:

> The Virgin statue, newly painted, stands
> with small white seashells at her feet,
> yellow painted stars around her ankles.
> It is a woman's garden
> and the clematis stand tall
> over the side wall like teenage girls
> with long hair running and laughing in the sunlight;
> No one can catch them.

The hydrangea rules all these complicated feelings about love, despair, forgiveness, and remorse. Rilke, in despair about not working, would be overcome with emotion and transformed by the sight of flowers and animals: ""I begin to see anew: already flowers mean so infinitely much to me, and from animals have come strange intimations and promptings. And sometimes I perceive even people so, hands live somewhere, mouths speak, and I see everything more quietly and with greater justice." In essence, *Hydrangea* is a book about seeing the world anew, about the ways in which flowers and animals prompt us to look inside ourselves, to listen to the stories they have to tell us.

Gloria Monaghan's *Hydrangea* takes the reader to a place where we learn that watching the world, and the behavior of animals, can teach us about ourselves, where breathing and meditation is an important skill, and that listening to sounds can enlighten you; it is a world where there is no separation between man and animal, but where suffering is also a necessary part of existence; it is a book of longing and desire and the possibility of love. It is a book where the hydrangea, among many other

flowers, offer the keys to our being and enlighten us about the mysteries of our nature. I would like to close this essay with a quote from William Wordsworth that I was reminded of when reading *Hydrangea*: "Great God! I'd rather be / A Pagan suckled in a creed outworn; / So might I, standing on this pleasant lea, / Have glimpses that would make me less forlorn; / Have sight of Proteus rising from the sea; / Or hear old Triton blow his wreathed horn."

BROOK J SADLER, PH. D.

## Review: **Making Landfall with *Shoreless* by Enid Shomer**

Persea Books, 2020 ($15.95)

It is a pleasure to read Enid Shomer's most recent book of poems, *Shoreless*, winner of the 2019 Lexi Rudnitsky Editor's Choice Award. Here is a mature poet who has something to say and who understands the power of form. This is not to say that her poems are without feeling—far from it—but the evocation and representation of emotion in Shomer's poems does not preclude the deeper and more essential work of generating solid meaning or grasping truths whose application extends beyond the individual poet's experience or zone of identity. (The book opens with two epigraphs that orient us to the poet's truth-seeking efforts; both speak to truth as an overwhelming force.)

The first poem, "Rara Omnia," communicates feelings of loss, as Shomer laments the diminishment of sea life as a result of "oil spills and red tides." However, the feeling of loss is not itself the poem's *raison d'être*. And though it opens in the first-person singular—"If there's life after death, it isn't the body/I'd want"—it positions the poem's speaker as a witness not simply of her own feeling but of the beauty of the natural world, which is being ravaged and destroyed. What she wants is to participate in creating a record of the beloved sea creatures who "spend/ themselves in extravagant numbers." What she wants after death is "to come back as pure voice," which is to say, her ambition is that her poems will continue to speak after she herself is gone. This is precisely the ambition of any true artist; it also reflects the urgency of an older poet for whom it is not the construction of an identity that is at stake, but the loss of the world. The ambition to make a record of the world is not the ego-centric project of stamping one's place in it, but the desire to share one's love of it—here, a love of sea life that is simultaneously a love of language. The inventory of creatures includes "the leathery leis of the lightning whelk,/the castanets of conchs with dozens of baby/ gastropods inside each disk of salty milk." The poet's musical language, as well as the musical metaphor of "castanets," not only records the creatures, but generates a sonic register that mimics their visual aspect.

The poet's encounter with the world becomes indistinguishable from the world, as language is a world-making device. The poem is presented in tercets strung together with rhymes and near rhymes, never forced, but always deliberate. To take a few examples: turtles/hurtled, surf/scarf, wrack/polychete/back. The formal constraints are no gimmick. The tercets and rhymes provide pacing that lends authority to the poet's voice; the reader feels guided rather than abandoned.

Several poems in Shomer's collection document the natural world—birds, beaches, trees, weeds, and water. Even without direct mention of climate change or environmental degradation, the essential metaphorical power of the natural in these poems attests to its value. Shomer's poems display how important it is to our understanding of the human condition to be able to encounter the natural. The healing value of the natural world consists not just in the warmth of the sun or the beauty of flowers, but in the transformation of ourselves that occurs when we recognize our own naturalness. Shomer's recognition, enacted through poetic language, is a gift of translation. In "Survival in the Thirteenth Year," she reflects on the experience of breast cancer. Pain and anxiety are projected into the description of "a branch of nickernut/its ferocious spiked pods/and thorny canes reminders/that life can be vicious." The poet is also direct: "Nature feels like a friendship/the world offers. Miraculous/we are all here: the wildflowers/in their magical diversity,/me abiding like a wind-stunted/tree." What I find especially valuable in lines like these is the willingness to make an assertion rather than rely upon a gesture or evasive associations. The poetic craft is undeniable—rhyme, image, simile—but the poet is also saying something definite and discernible.

At the center of the book, a long poem, "Pausing on a Hillside in Anatolia," provides one of the most beautiful paeans to sound that I have seen in recent poetry. I'd buy the book just to study this one poem's extraordinarily graceful evocation of sounds. But, here, too, Shomer does not disappoint by leaving the reader merely to *listen* to more than one-hundred lines of image-rich, sonically gorgeous, carefully wrought stanzas. Again, she has something to say. Near the poem's close, she asks, "Well I have lived in a punishing wind//for years now, but how many bells/could I summon?" The bells have become a symbol of the

poet's ability to locate and relay truth in words. The initial answer shows how large her scope is: "Never enough for the century's/slaughter." What begins with personal observation and memory, concludes with a commentary on the power of language to bear witness to more than individual experience. If poets forfeit these larger possibilities—the capacity of poetry to speak outside of our identity zones—poetry will collapse into the cacophony of moral relativism or a multi-vocal, but impotent subjectivism.

Shomer's "Villanelle for My Two Spines" is an excellent example of the way that form can enact and enhance a poem's meaning, inviting the reader to participate in the order created by form. Here, the titular two spines are the literal "chain of bones," which has caused tremendous pain, and the "titanium disks" that the surgeon has implanted, which form a "scaffolding" to support the bones. But the villanelle itself is another scaffolding, another "cage," that contains the poet's pain, making it into a "bearable ache." The same lines and images divorced from the demands of the villanelle as a form would be comparatively limp. Form is constitutive of meaning, which exceeds emotional expressiveness.

In his well-known and, ironically, often-studied poem, "Introduction to Poetry," Billy Collins amusingly parodies students' attempts to "torture a confession" out of a poem. Collins' evident complaint is that a poem is not made in order to be analyzed, not written in order to make a point. The poem need not have anything to confess, no ultimate secret to reveal. And applying more pressure to the analysis of a poem will not necessarily give the reader greater satisfaction with it. I concur. Yet, we can forego the reduction of poems to a point without forsaking the poet's ability to say something definite and meaningful. We can embrace a poem's formal structure as a guide to meaning without losing the poet's individuality or feeling and without limiting its imaginative reach. As with other arts, the ability to discern at least some of the disciplinary techniques that constitute the specific form of the art—distinguishing poetry from prose, for example—will augment the reader's enjoyment. Shomer's poems are a pleasure to read because of what they have to say about mortality, aging, erotic love, illness, family,

and the kinship of poets (Keats and Shelley make special appearances), among other things. And the saying of these things is inseparable from her embrace of the formal elements of craft. I would encourage everyone to write about what they feel and who they are. But I would have publishers spend more time with poets like Shomer who have sounded the deeper resources of substance and form.

EILEEN CLEARY
Review: *Listen* **by Steven Cramer**
Mad Hat Press, 2021 ($19.95)

When I heard that Steven Cramer's sixth poetry collection was to be published, I anticipated a polished symphony of accomplished, intelligent, and engaging verse. *Listen* did not disappoint. The scope and concerns of the poetry is impressive: depression, group therapy, grief, a shopping cart at Costco filled and "heavy as a Fiat," children and spouses, Whitman, a look at the poet's "thinking about thinking" on an elliptical, and Zuni fetishes, to touch on just a hint of the domains this verse occupies. This variety could pique any reader's interest.

Although I read Cramer because his poems are never boring, always erudite, witty, sometimes comical, self-effacing, and often enough surreal, I must confess. None of these reasons are why I am excited with each new poem, each new book that he publishes.

It is that I crave each treatise on craft.

I read because I yearn for the immaculate descriptions, which I first encountered in Cramer's poem "The Hospitals," published by *Poetry* in August 1988. In that poem, it is the season that fathers have been "wheeled off half-mown lawns" into the hospitals where they are made to fit into "astonishingly narrow beds." To my delight, flawless and apt descriptions occur thirty years later in *Listen*. In "The World," the speaker grapples with intense depression and an uncertain future. How profoundly does he grapple? So much so that, "That whole summer my black razor-point/pens, when laid side by side, looked like bodies in body bags."

I read Cramer because I want to see if it is possible for a poet to retain such assurance with figurative language. Here again, I bring up "The Hospitals." Witness the exquisite workaday of these similes.

And they keep the fathers in the hospitals
as if they'd turned up there, like unclaimed luggage,

never to be shipped to their proper address.

119

And later,

> ..................... Knowing no better,
> they'll let us believe they once fed the earth,
> their lives as deliberate as money.

There is always something desolate about abandoned luggage, but sadder still for a father to transform to a homeless object. Who among us does not believe, at least while reading this poem, that fathers feed the earth? "The Hospitals," which I encourage you to read, invites us into shared human experience and deepens this by simile. Over three decades later, the poet's mastery is intact, if not heightened. *Listen*, too, expands its dimensions with figurative language. For instance, in "Lackawanna" the speaker is having a diagnostic scan due to neurological symptoms:

> I couldn't love
> songs I loved; Friends came
>
> nameless as mailmen ...
> A loaf of dough
> forbidden to rise.

Another extraordinary thing that *Listen* does is allow a moment of silence within its poems for the stark realities outside of them. This happens in "American Freedom" as the speaker admits "When the obits of seventeen students grin/from *The Times* and *The Globe*, for a day or two//poetry feels shifty, a stump speech."

Often, the poems in *Listen* grapple with melancholy. Often, in grief. These vital poems sometimes exist in remembered light. They dwell in wedding videos where couples are no longer couples. They perseverate. They wonder and wander into "the bedlam of thought." They dream of fireflies, or if you prefer, lightning bugs. These poems are occasionally as "quiet as whispered scripture," or they are loud enough to "shoot muskets and pretend to kill." They poke fun. They "understand modern culture" and "fondue." They travel and are well read. They gargle and they sing.

I invite you to read *Listen* and enjoy this smorgasbord, made cohesive by their sure voice and formal nods. Read and re-read to the very "last line." This poetry has already proven to stand the test of time.

STEPHANIE ARNETT is a Boston-based photographer and artist. She fosters an ambiguity in scale and perspective, often working with images that are "made" both before and after capture—constructed landscapes, arranged still life, stitched panoramas. Her work has been recognized by *Photo District News*, the Magenta Foundation, and has been shown in the Danforth and Griffin Museums.

MARÍA LUISA ARROYO, multi-lingual poet, translator, and former poet laureate of Springfield, MA, is the author of *Gathering Words|Recogiendo palabras* and *Destierro Means More than Exile*. Assistant Professor of Writing and First-Year Studies at Bay Path University, she received the Der-Hovanessian Prize in 2019.

JENNIFER BADOT is a poet based in Somerville, Massachusetts. Her debut collection, *The Blue House and the Dawn*, is forthcoming from Lily Poetry Review Books. Badot's poems have appeared in *The Boston Globe*, *The Boston Phoenix Literary Supplement*, *Stuff Magazine*, *lift*, *Studia Mystica* and elsewhere.

BRANDY BARENTS lives in Cambridge and teaches in the Writing Program at Boston University. Her work has appeared in *236*, *The American Literary Review*, *Barrow Street*, and *The Country Dog Review*.

ROY BENTLEY, finalist for the Miller Williams prize for his book *Walking with Eve in the Loved City*, is the author of seven books of poetry; including, most recently, *American Loneliness* from Lost Horse Press, who is bringing out a new & selected in 2020. He has published poetry in *december*, *The Southern Review*, *New Letters*, *Crazyhorse*, *Shenandoah*, *Blackbird*, *Prairie Schooner*, and *Rattle* among others.

BRETT BIEBEL teaches writing and literature at Augustana College in Rock Island, IL. His (mostly very) short fiction has appeared in *Chautauqua*, *SmokeLong Quarterly*, *The Masters Review*, *Emrys Journal*, and elsewhere. *48 Blitz*, his debut story collection, will be published in December 2020 by Split/Lip Press. You can follow him on Twitter @bbl_brett.

ELISABETH BLAIR is a poet based in Vermont. She has been artist-in-residence at ACRE, Kimmel Harding Nelson Center for the Arts, and Atlantic Center for the Arts. Her publications include *We He She/It*, a chapbook (Dancing Girl Press, 2016), *without saying*, a forthcoming chapbook (Ethel Press, 2020), and poems in a variety of journals, including *Feminist Studies* and *cream city review*. She is currently honored to lead the poetry workshop for the Burlington Writers Workshop in Vermont. www.elisabethblair.net

ACE BOGGESS is author of five books of poetry—*Misadventure*, *I Have Lost the Art of Dreaming It So*, *Ultra Deep Field*, *The Prisoners*, and *The Beautiful Girl Whose Wish Was Not Fulfilled*—as well the novels *States of Mercy and A Song Without a Melody*. His writing appears in *Notre Dame Review*, *The Laurel Review*, *River Styx*, *Rhino*, *North Dakota Quarterly*, and other journals. He received a fellowship from the West Virginia Commission on the Arts and spent five years in a West Virginia prison. He lives in Charleston, West Virginia.

WENDY BOOYDEGRAAFF holds a Master of Education degree from Grand Valley State University and a graduate certificate in children's literature from Penn State. She is the author of *Salad Pie,* a children's picture book published by Ripple Grove Press. Her work has been published in *Third Wednesday, SmokeLong Quarterly, Bending Genres, Critical Read, Across the Margin,* and *Jellyfish Review,* and is forthcoming in *So It Goes, Border Crossing, Whistling Shade,* and *NOON.*

SHIRLEY J. BREWER serves as poet-in-residence at Carver Center for the Arts & Technology, a high school in Baltimore, MD. She also teaches creative writing workshops for seniors – sponsored by *Passager Books.* Recent poems appear in *Poetry East, Barrow Street, Chiron Review, Comstock Review, Gargoyle, Slant,* and many other journals and anthologies (including *Nasty Women Poets* published by Lost Horse Press). Shirley's poetry books include *A Little Breast Music* (Passager Books, 2008), *After Words* (Apprentice House, 2013), and *Bistro in Another Realm* (Main Street Rag, 2017). In January, 2020, Shirley was interviewed at the Library of Congress by Maryland poet laureate, Grace Cavalieri, for her long-running series "The Poet and the Poem." www.apoeticlicense.com

MARY BUCHINGER is the author of four collections of poetry: *Navigating the Reach* (forthcoming), *e i n f ü h l u n g/in feeling* (2018), *Aerialist* (2015) and *Roomful of Sparrows* (2008). She is president of the New England Poetry Club and Professor of English and communication studies at MCPHS University in Boston. Her work has appeared in *AGNI, Diagram, Gargoyle, Nimrod, [PANK], Salamander, Slice Magazine, The Massachusetts Review,* and elsewhere; her website is www.MaryBuchinger.com.

PAULA CAMACHO is a nationally-exhibiting artist who is receiving her Bachelor of Fine Arts degree in Fall of 2019. She works predominantly in painting. She has been an artist-in-residence at the New York Academy of Art, as well as participated in numerous group-shows throughout Florida. Paula plans to pursue more artist residencies in the future and continue developing her spiritual life, which consequently informs her Artwork.

BARBARA SIEGEL CARLSON is the author of 2 poetry collections, *Once in Every Language* (Kelsay Books, 2017) and *Fire Road* (Dream Horse Press, 2013), co-translator of two books of poems by Srečko Kosovel and co-editor of *A Bridge of Voices: Contemporary Slovene Poetry and Perspectives.* She is one of 5 poets featured in *Take Five,* a collection of prose poems, due out in May from Finishing Line Press.

NEIL CLARK is a writer from Edinburgh, Scotland. His work has been nominated for Best Small Fictions, Best Microfiction and Best of the Net, and can be found in places such as Jellyfish Review, Wigleaf and Hobart After Dark. His debut collection of cosmic fiction is called *Time. Wow,* and is out now on Back Patio Press. Find him on Twitter @NeilRClark or visit neilclarkwrites.wordpress.com for a full list of publications.

PAULA COLANGELO received an MFA in Poetry from Drew University. Her poetry is published in *Connotation Press: An Online Artifact*, and her book reviews appear in *Pleiades* and *Rain Taxi*. She has taught poetry in a healing focused program at a rehabilitation center in New Jersey.

JAILENE CORDERO is a Puerto Rican writer and digital illustrator, living in Illinois, United States.

CHELLA COURINGTON is a writer and teacher whose poetry and fiction appear or are forthcoming in numerous anthologies and journals including *SmokeLong Quarterly, The Collagist,* and *The Los Angeles Review*. Her novella, *Adele and Tom: The Portrait of a Marriage,* is available at Breaking Rules Publishing. Originally from the Appalachian South, Courington lives in California with another writer and two cats (chellacourington.net).

LILIA DOBOS is a graduate teaching assistant at Salisbury University. Her academic achievements include receiving a Killam Fellowship with Fulbright Canada and being a Fulbright semifinalist. Her poems have been published in *Barely South Review, New Mexico Review, The Shore,* and elsewhere.

GABE DURHAM is the author of three books, including a novel in monologues, *FUN CAMP* (Publishing Genius, 2013). His writings have appeared in the *TLR, Barrelhouse, Hobart, Puerto Del Sol,* and elsewhere. He lives in Los Angeles where he runs Boss Fight Books.

KAREN FRIEDLAND is a nonprofit grant writer by day. Her poems have been published in *Nixes Mate Review, Writing in a Women's Voice, Lily Poetry Review, Vox Populi* and others. She currently has a poem hanging on the walls of Boston's City Hall, selected by Boston's Poet Laureate. Her book of poems, *Places That Are Gone,* was published in 2019 by Nixes Mate Books, and she has a chapbook forthcoming in late 2020. Karen is a member of Cervena Barva Press and is a founding member of the Boston-based Poetry Sisters collective.

ROBBIE GAMBLE's poems and essays have appeared in the *Atlanta Review, Cider Press Review, RHINO, Rust + Moth, Scoundrel Time,* and *Tahoma Literary Review*. He was the winner of the 2017 *Carve* Poetry prize and held a 2019 Peter Taylor fellowship in nonfiction at the Kenyon Summer Writers Workshop. He is the associate poetry editor at *Solstice: A Magazine of Diverse Voices,* and he divides his time Between Boston and Vermont.

CAPRICE GARVIN is a native New Mexican, currently residing in New Jersey. She studied in the Writing Division at Columbia University, where she was awarded The Woolrich Award for Excellence in Writing, and in the Writing Division at Sarah Lawrence College where she earned an M.F.A. in fiction. Her poetry has been published in *Indolent Books (What Rough Beast poetry series), Glass: A Journal of Poetry (Poets Resist series),* and *The New Verse News*.

NAKUL GROVER holds a master's degree in English, and undergraduate

degrees in Chemical Engineering and English from Penn State's Schreyer Honors College. He is currently working on a novel about climate change migration, sexuality, and religion. He has won 15+ awards across fiction, poetry, and the essay.

TODD HELDT is a librarian in Chicago. His first collection of poetry, *Card Tricks for the Starving*, was published by Ghost Road Press. Other things written under various pseudonyms have appeared in print, on the internet, and on movie screens. Since becoming a father his biographical statement has less time to be interesting. His work has appeared recently in *2AM Muse, Anti-, Black Tongue Review, Blast Furnace, Chiron Review, The Ekphrastic Review, The Fear of Monkeys, Gyroscope Review, Modern Poetry Quarterly, Requiem, Rue Scribe, Sundress,* and *ThreePenny Review.*

MARK JEDNASZEWSKI grew up in Tampa and studied marine engineering at Kings Point. He splits his time between Philadelphia and at sea, as the chief engineer on a deep ocean car carrier. He received his MFA from the Solstice Program of Pine Manor College, where he was the 2018 Dennis Lehane Fiction Fellow. His fiction has been nominated for Best of the Net, appearing in Mineral Lit, Gravel, and elsewhere. His fiction chapbook *Scales of the Ouroboros* will be published by the Cupboard Pamphlet in May 2021. Connect with him on Twitter: @ninjaneerski.

K. CARLTON JOHNSON's work has appeared in *Rattle, MacGuffin, The Diner* and *Barely South*. Both poet and visual artist, living on the shores of Lake Superior.

CHRISTINE JONES is founder/editor of *Poems2go* and an associate editor of *Lily Poetry Review*. Her poems have appeared in numerous literary journals including *32 poems, cagibi, Pangyrus, Sugar House Review, Mom Egg Review,* and elsewhere. She is the author of the full-length poetry book, *Girl Without a Shirt* (Finishing Line Press, 2020) and co-editor of the recently released anthology, *Voices Amidst the Virus: Poets Respond to the Pandemic* (Lily Poetry Review Books, 2020). She resides in Cape Cod, MA.

MILTON JORDAN lives in Georgetown, Texas, with his wife, the musician Anne Jordan. He has published essays, poems, reviews, and stories in literary and general circulation journals. His most recent poetry collection is *What the Rivers Gather* (Stephen F. Austin University Press, 2020). Milton edited the anthology, *No Season for Silence: Texas Poets and Pandemic* (Kallisto Gaia Press, 2020).

JURY S. JUDGE is an internationally published artist, writer, poet, and political cartoonist. Her 'Astronomy Comedy' cartoons are published in Lowell Observatory's quarterly publication, *The Lowell Observer*. She has been interviewed on the television news program, 'NAZ Today' for her work as a political cartoonist. Her artwork has been widely featured in over one hundred literary magazines such as, *Blue Mesa Review, The Tishman Review, Blue Moon Review,* and *The Ignatian Literary Journal*. She graduated Magna Cum Laude with a BFA from the University of Houston-Clear Lake in 2014.

LAURA HOFFMAN KELLY is a United States Marine Corps Veteran currently enrolled in The University of Tampa's MFA in Creative Writing Program. Her most recent work is forthcoming or appears in: *2River, Miracle Monocle, Hyperlimenous, Bop Dead City, Enizagam, Typishly, The Bangalore Review, The Gyroscope Review, Poetry Circle, The Ibis Head Review, Chaleur Magazine, The Write Launch, Night Picnic, Noir Nation, Left Hooks, Flypaper Magazine, Pouch, Lady Blue Literary Magazine,* and *WOWsdom:The Girl's Guide To The Positive and The Possible* created by Donna Orender. Hoffman is also the winner of the 2018 Wainright Award for Poetry.

RICHARD KOSTELANETZ's work appears in various editions of *Readers Guide to Twentieth-Century Writers, Merriam-Webster Encyclopedia of Literature, Contemporary Poets, Contemporary Novelists, Postmodern Fiction, Webster's Dictionary of American Writers, The HarperCollins Reader's Encyclopedia of American Literature, Baker's Biographical Dictionary of Musicians, Directory of American Scholars, Who's Who in America, Who's Who in the World, Who's Who in American Art, NNDB.com, Wikipedia.com,* and *Britannica.com,* among other distinguished directories. Otherwise, he survives in New York, where he was born, unemployed and thus overworked.

KIMAYA KULKARNI is a writer living in and constantly being inspired by her hometown, Pune. She is a founding member of *decoloniszing our bookshelves* and editor of *Bilori Journal.* Her prose has been published in *Wizards in Space, Honey and Lime* and *ROM Mag.*

ASHLEY KUNSA's creative work appears in many venues including *The Writer, Sycamore Review, The Los Angeles Review,* and *Quarter After Eight.* She is assistant professor of creative writing at Rocky Mountain College in Billings, MT, and editor-in-chief of *genre2,* an online literary journal devoted to publishing authors' best work outside their primary genre. You can find her online at www.ashleykunsa.com.

JAN LAPERLE lives outside of Fort Knox, Kentucky with her husband, Clay Matthews, and daughter, Winnie. She has published a book of poetry, *It Would Be Quiet* (Prime Mincer Press, 2013), an e-chap of flash fiction, *Hush* (Sundress Publications, 2012), a story in verse, *A Pretty Place To Mourn* (BlazeVOX, 2014), and several other stories and poems. In 2014 she won an individual artist grant from the Tennessee Arts Commission. She is a master sergeant in the US Army.

JASMINE LEDESMA lives in New York. Her work can be found in places such as *Glitter MOB, Gone Lawn, NBGA of Vice* and *[PANK]* among others. She was nominated for both Best of The Net and the Pushcart Prize in 2020.

KALI LIGHTFOOT's poems and reviews of poetry books have appeared in journals and anthologies, including *Lavender Review, Broadsides to Books, Amethyst Review,* and *Gyroscope.* Her work has been nominated twice for Pushcart Prize, and once for Best of the Net. Kali earned an MFA at Vermont College of Fine Arts in 2015, and her debut collection is forthcoming from CavanKerry Press

in April, 2021.

EVE F.W. LINN received her B.A. cum laude from Smith College in Fine Art and her M.F.A. in Poetry from the Low Residency Program at Lesley University. She has attended the Bread Loaf Writer's Conference, the Frost Place Conference on Poetry, and the Colrain Manuscript Conference. She is a published poet and book reviewer. Her first chapbook, *Model Home* (2019), is available from River Glass Books. Her favorite color is blue. She collects antique baby shoes, vintage textiles, and art pottery. She lives west of Boston with her family and one demanding feline.

FRANCES MAC hails from the Texas Hill Country and currently lives in Washington, DC. Her poems have recently appeared in *The MacGuffin, Santa Clara Review, The Northern Virginia Review,* and *Steam Ticket.* Learn more about her work at www.francesmacpoetry.com.

MARTHA McCOLLOUGH is a writer living in Amherst, Massachusetts. She has an MFA in painting from Pratt Institute. Her poems have appeared or are forthcoming in *Radar, Zone 3, Tammy, Pangyrus,* and others. Her chapbook, *Grandmother Mountain,* was published by Blue Lyra Press.

LAURIE McCULLOCH's poetry has appeared in *After the Pause.* She lives in Turner Valley, AB, and writes with a view of the Rockies in her kitchen window.

BRUCE McRAE, a Canadian musician currently residing on Salt Spring Island BC, is a multiple Pushcart nominee with over 1,600 poems published internationally in magazines such as *Poetry, Rattle* and *the North American Review.* His books are *The So-Called Sonnets* (Silenced Press); *An Unbecoming Fit of Frenzy* (Cawing Crow Press); *Like As If* (Pski's Porch); and *Hearsay* (The Poet's Haven).

JESSICA MEHTA is the author of several books and currently a fellow at Halcyon Arts Lab in Washington DC where she is curating an anthology of poetry by incarcerated indigenous women. As a citizen of the Cherokee Nation, it is a passion project years in the making. Find out more at www.jessicamehta.com.

MARK J. MITCHELL was born in Chicago and grew up in southern California. His latest poetry collection, *Starting from Tu Fu* was just published by Encircle Publications. A new collection is due out in December from Cherry Grove. He is very fond of baseball, Louis Aragon, Miles Davis, Kafka and Dante. He lives in San Francisco with his wife, the activist and documentarian, Joan Juster where he makes his meager living pointing out pretty things. He has published 2 novels and three chapbooks and two full length collections so far. Titles on request. A meager online presence can be found at https://www.facebook.com/MarkJMitchellwriter/

CARLA PANCIERA has published two collections of poetry: *One of the Cimalores*

(Cider Press) and *No Day, No Dusk, No Love* (Bordighera). Her collection of short stories, *Bewildered*, received AWP's 2013 Grace Paley Short Fiction Award. Her work has appeared in several journals including *Poetry, The New England Review, Nimrod, The Chattahoochee Review, Painted Bride,* and *Carolina Quarterly.* A high school English teacher, Carla lives in Rowley, MA.

ALIX PHAM is an emerging poet. She is published with *DiaCRITICS* (March 2021) and *Brooklyn Poets* as *Poet of the Week.* She is Lead for the Westside Los Angeles chapter of Women Who Submit, a volunteer-run literary organization supporting and nurturing women and non-binary writers. She is the recipient of Brooklyn Poets Fellowship, the Association of Writers and Writing Programs' Writer-to-Writer Mentorship Program and PEN Center / City of West Hollywood Writing Craft Scholarship in Fiction and Nonfiction. She bakes and brews while writing poetry and prose.

ISAAC RANKIN lives in Asheville, NC. He works at an all-boys boarding school, Christ School, where he serves as Associate Director of Advancement. Isaac has worn many hats in education, including administrator, teacher, coach, and bus driver. Working in schools is Isaac's calling, but he also enjoys traveling near and far, following sports obsessively, reading and writing across genres, and chasing his son in the backyard. His poems have appeared in *Apeiron Review, Aethlon,* and *Sky Island Journal.*

ANNE RIESENBERG work has recently appeared in *Pleiades, Posit, The New Guard's BANG!, Heavy Feather Review, What Rough Beast, Naugatuck River Review,* and elsewhere. Anne has won the *Blue Mesa Review* Nonfiction and *Storm Cellar* Force Majeure contests and was a finalist in the Noemi Press Prose and Essay Press Book contests. She practices 5 Element acupuncture in Newcastle, Maine.

BROOK J. SADLER, Ph.D. publishes poetry and essays in numerous literary journals, including *The Greensboro Review, Tampa Review, Missouri Review, Pleiades, The Cortland Review, Ms. Magazine, Women's Review of Books,* and *Aquifer: Florida Review* online. She is a professor of philosophy in the Department of Humanities and Cultural Studies at the University of South Florida.

RIKKI SANTER's work has appeared in various publications including *Ms. Magazine, Poetry East, Slab, Crab Orchard Review, RHINO, Grimm, Hotel Amerika* and *The Main Street Rag.* Her work has received many honors including five Pushcart and three Ohioana book award nominations as well as a fellowship from the National Endowment for the Humanities. Her eighth collection, *Drop Jaw,* inspired by the art of ventriloquism, was published this spring by NightBallet Press.

ANDY SMART earned his MFA in Creative Nonfiction at the Solstice Low-Residency program at Pine Manor College. His work has appeared in *Lily Poetry Review, River Heron Review,* and elsewhere, and is forthcoming in *Glassworks* and *The American Journal of Poetry.* His first chapbook, *Blue Horse Suite,* is available

now from Kattywompus Press. Andy lives in St. Louis and online at www.andysmartwrites.com.

SUSAN SOLOMON is a freelance paintress living in the beautiful Twin Cities of Minneapolis Saint Paul. Her paintings are in the University collections of Metropolitan State and Purdue. Her work focuses on the intersection of intuition and physical geography.

SAMN STOCKWELL has published in *Agni, Ploughshares,* and *The New Yorker,* among others. Her two books, *Theater of Animals* and *Recital,* won the National Poetry Series and the Editor's Prize at Elixir, respectively. Recent poems are in *Gargoyle, Smartish Pace, The Literary Review* and are forthcoming in *Plume* and others.

LISA C. TAYLOR's new fiction or poetry has been published in *Crannog, Map Literary, Tahoma Literary Review,* and *WomenArts Quarterly Journal.*

PETER URKOWITZ lives in Salem, Massachusetts, where he works in a college library. He has published poems and art in *Meat for Tea: The Valley Review, Oddball Magazine, Sextant,* and the *Lily Poetry Review.* His *Fake Zodiac Signs* have been recently published in a chapbook from Meat for Tea Press.

PETER VALENTE is the author of eleven full length books, including a translation of Nanni Balestrini's *Blackout* (Commune Editions, 2017), which received a starred review in Publisher's Weekly. His most recent book is a co-translation of *Succubations and Incubations: The Selected Letters of Antonin Artaud 1945-1947* (Infinity Land Press, 2020). Forthcoming is a book of essays, *Essays on the Peripheries* (Punctum Books, 2021), and his translation of *Nicolas Pages* by Guillaume Dustan (Semiotext(e), 2022).

CONNEMARA WADSWORTH's chapbook, *The Possibility of Scorpions,* about the years her family lived in Iraq in the early 50's, won the White Eagle Coffee Store Press 2009 Chapbook Contest. Her poems are forthcoming or appeared in *Prairie Schooner, Solstice, San Pedro River Review, Smoky Blue Literary & Arts Magazine,* and *Valparaiso.* "The Women" was nominated for publication in Pushcart Prize Best of the Small Presses by Bloodroot Magazine. Connemara and her husband live in Newton, Massachusetts.

SARAH WALKER is a flash fiction editor for Lily Poetry Review. She was the 2017 Dennis Lehane Fiction Fellow at the Solstice MFA Creative Writing Program of Pine Manor College. Her work has appeared in *American University: Folio, Burrow Press Review, BULL, Cleaver, Colorado Review,* and *New Limestone Review,* among others. She lives in Lowell, MA and is an educator at The Walden Woods Project.

ANNA M. WARROCK's latest book is *From the Other Room,* Slate Roof Press Chapbook Award winner. Besides appearing in *The Sun, The Madison Review, Harvard Review,* and other journals, her work is anthologized in *Kiss Me Goodnight,*

women writing on childhood mother-loss, a Minnesota Book Award Finalist. Her poems have been choreographed, set to music, and inscribed in a Boston area subway station. She has held seminars on understanding grief and loss through poetry. www.AnnaMWarrock.com

KEVIN RICHARD WHITE's fiction appears in *The Hunger, Lunch Ticket, The Molotov Cocktail, The Helix, Hypertext, decomP, X-R-A-Y* and *Ghost Parachute* among others. He is a Flash Fiction Contributing Editor for *Barren Magazine*. He lives in Philadelphia.

MARTIN WILLITTS JR. has 24 chapbooks including the winner of the Turtle Island Quarterly Editor's Choice Award, *The Wire Fence Holding Back the World* (Flowstone Press, 2017), plus 16 full-length collections including the Blue Light Award 2019 winner *The Temporary World*. His recent book is *Unfolding Towards Love* (Wipf and Stock). He is an editor for the *Comstock Review*.

WOODY WOODGER lives in Lenox, Massachusetts. Her work has appeared, or is forthcoming, from *DIAGRAM, Drunk Monkeys, RFD, Exposition Review, peculiar, Prairie Margins, Rock and Sling*, and Mass Poetry Festival, among others, and her poetry has been nominated for Best of the Net. Her first chapbook, *postcards from glasshouse drive* (Finishing Line Press) has been nominated for the 2018 Massachusetts Book Awards. In addition, Woodger served as Poet in Residence with the Here and Now in Pittsfield, MA. You can find her essays on Medium. com @Rosebedwetters.

HALEY WOONING lives in California with her partner and cat, Puck. Her book of poetry, *Mothmouth*, is available from Spuyten Duyvil.

KUO ZHANG is a faculty member at Western Colorado University. She has a bilingual book of poetry in Chinese and English, Broadleaves (Shenyang Press). Her poem "One Child Policy" was awarded second place in the 2012 Society for Humanistic Anthropology [SHA] Poetry Competition held by the American Anthropology Association. She served as poetry & arts editor for the *Journal of Language & Literacy Education* in 2016-2017 and also one of the judges for 2015 & 2016 SHA Poetry Competition. Her poems have appeared in numerous literary magazines, including *Gyroscope Review, Coffin Bell Journal, The Roadrunner Review, Mom Egg Review, Bone Bouquet, K'in, North Dakota Quarterly, Rigorous, Adanna Literary Journal, Raising Mothers,* and *MUTHA Magazine*.

CPSIA information can be obtained
at www.ICGtesting.com
Printed in the USA
BVHW020055060421
604264BV00025B/253